HARD PRESSED

600 Years of Prints and Process

HARD PRESSED

600 Years of Prints and Process

DAVID PLATZKER *and*

ELIZABETH WYCKOFF

HUDSON HILLS PRESS, NEW YORK

In association with International Print Center New York

First Edition

© 2000 by International Print Center New York.

Published in the United States by Hudson Hills Press, Inc.,
1133 Broadway, Suite 1301, New York, NY 10010-8001.

Distributed in the United States, its territories and possessions, and Canada by National Book Network.

Editor and Publisher: Paul Anbinder

Manuscript Editor: Virginia Wageman

Proofreader: Lydia Edwards

Indexer: Karla J. Knight

Designer: Howard I. Gralla

Composition: Angela Taormina

Manufactured in Japan by Toppan Printing Company.

Library of Congress Cataloguing-in-Publication Data

Platzker, David, 1965–
 Hard pressed: 600 years of prints and process / David Platzker and Elizabeth
 Wyckoff. — 1st ed.
 p. cm.
 "In association with International Print Center New York."
 Includes bibliographical references and index.
 ISBN: 1-55595-192-9 (cloth: alk. paper)
 1. Prints — Technique — History. I. Wyckoff, Elizabeth. II. Title.

NE400 . P58 2000
769.9 — dc21
 00-40935

Contents

Foreword

ΤHIS CATALOGUE accompanies International Print Center New York's inaugural exhibition *Hard Pressed: 600 Years of Prints and Process,* opening at The AXA Gallery in New York in November 2000. It represents the first public presentation of this not-for-profit institution dedicated to the greater appreciation and understanding of artists' prints worldwide.

As the speed of technological change accelerated during the twentieth century, artists responded by incorporating new techniques into their work in innovative and surprising ways. Laser printing, computer-generated images, virtual imaging — all made their way into the printmaker's studio, stretching and challenging our definitions of the original print and of art. But was this new? International Print Center New York asked Elizabeth Wyckoff, Print Specialist at the New York Public Library, and David Platzker, Director of Printed Matter, to together consider the question. They answer it here with this dazzling and wide-ranging selection of images culled from six hundred years of history of the original print.

In addressing a timely subject, yet embracing all time periods, many cultures, and many media of printmaking, *Hard Pressed* suggests the broad sweep of IPCNY's exhibitions to come. Over time, an array of loan exhibitions varied in genesis and theme, drawn from public and private collections around the world, will be organized for public presentation. In tapping the combined expertise of two highly talented independent curators for this first exhibition, IPCNY's mandate is clearly set forth: to bring fresh intelligence to the examination and interpretation of the original print. The results are superb, and we rejoice in sharing them and documenting them for future generations of scholars. With *Hard Pressed,* a milestone is marked, and an extraordinary moment in the long evolution of fine art printmaking is captured.

IPCNY salutes The AXA Gallery for offering our young institution the opportunity to mount its first exhibition in this major Manhattan venue. We thank AXA Financial Inc. and its subsidiary, The Equitable Life Assurance Society of the United States, for their most generous corporate sponsorship of the exhibition and accompanying programs. Grateful acknowledgment is offered to the Samuel H. Kress Foundation for its sponsorship of this publication, and to Furthermore . . . the Publication Program of the J. M. Kaplan Fund, the Joe and Emily Lowe Foundation, and the Eugene V. and Clare E. Thaw Charitable Trust for their commitment and support. This publication has been partially funded through the generosity of the International Fine Print Dealers Association, Inc., and by public funds from the New York City Department of Cultural Affairs, Manhattan Arts Development Fund.

We commend the great generosity of the lenders of these prints, each a treasure and together a revelation. The cooperation of artists, the museum and publishing communities, as well as private collectors has been extraordinary. We single out Trustees Leonard Lehrer and Amy Baker Sandback for their careful oversight of the planning for this exhibition and its catalogue. We recognize the outstanding philanthropy of Thomas C. Danziger, Esq., for his steadfast and gracious attention to our needs, as Counsel and member of IPCNY's Board of Trustees. We appreciate the initial and continuing commitment of our publisher, Paul Anbinder, to this, our first publication. And we thank Xandra Eden, former Exhibition

Assistant at IPCNY, and Jennifer Landes Presby, Curatorial Assistant, for their critical work on this project.

Following its New York run, *Hard Pressed* will travel across the United States, first to the Boise Art Museum in Boise, Idaho, then to the Museum of Fine Arts in Santa Fe, New Mexico, and the Naples Museum of Art in Naples, Florida. IPCNY has contracted the Technical Assistance Program of the American Federation of Arts to manage the tour. We are delighted that the audience for the exhibition will expand, and we are grateful for the institutional collaborations that have made this possible.

Lastly we wish to thank our founding members, Board of Trustees, Advisory Council, members, and many friends who believe in the concept of a print center and encourage us in our work. In particular we thank the Edward John Noble Foundation, whose support of our institution in its early days has made it possible for us to organize and tour this stunning and enlightening exhibition.

Anne Coffin, *Director*
International Print Center New York

Curators' Introduction: Pressing Forward

THIS CATALOGUE, a companion to the exhibition *Hard Pressed: 600 Years of Prints and Process,* examines the effects of technical advances in the history of printmaking as reflected in printed works by artists, focusing on examples that have expanded the boundaries of printmaking media. The central premise of the exhibition is that artists utilize new and old technologies in often unanticipated ways in the production of serial, printed artworks. The innovations sometimes go hand in hand with the most technologically advanced methods at a given time, while at other times they subvert such advances.

The practice of printing or stamping images onto paper is much more than six hundred years old, as the eleventh-century Chinese woodblock in the exhibition (no. 1) demonstrates. The Chinese were inking raised lines cut in wood and impressing them onto paper as early as the seventh century, and historians in the West have argued that the essential sculptural elements of traditional printmaking are as old as civilization. The practice of printmaking in the West, however, the subject of this exhibition and book, began in earnest only around 1400, coinciding with the introduction in Europe of the technology for making paper and an early modern demand for large numbers of readily produced images used for both leisure and devotional activities.

The early history of European printmaking is often viewed as one of successive stylistic improvement upon the craft, exemplified in the progression from the early outline devotional woodcuts of the fifteenth century to Albrecht Dürer's virtuoso crosshatched woodcuts of the 1490s. As new techniques evolved that were easier to manipulate, artists not primarily trained in the cutting of blocks or plates began to use them in unorthodox ways. The use of etching by painters is one prominent example from the sixteenth and seventeenth centuries; lithography received a similar response in the nineteenth century, as photographic and digital processes do today. Decisions by artists to "mix-and-match" printmaking methods — from the combinations of etching and engraving in the seventeenth and eighteenth centuries to Edvard Munch's union of lithography and woodcut and Robert Rauschenberg's liberation of the print from paper surfaces to a multitude of strata simultaneously — continue to push printmaking techniques forward. The history of prints is also marked by artists returning to traditional printmaking practices, as witnessed in the works of such nineteenth- and twentieth-century artists as Paul Gauguin, James McNeill Whistler, and Chuck Close. All of these developments occur in response to technological advances, but equally as a result of artists' attitudes toward artistic production.

Historically, the nature of the print as a multiple has been its most powerful characteristic. As a conveyor of information in exactly repeatable pictorial statements, the printed image has played a significant role in technological, scientific, and cultural developments. Since artists could promote their work in a much expanded marketplace by making prints themselves, or commissioning others to do so, printmaking quickly became a medium of substantive expression in the world of art. The growth and development of printmaking techniques, including the interactions between artist and printer as well as between the fine and decorative arts, have resulted in a multiplicity of expressive possibilities. New opportunities introduced through the constant intervention of new technologies keep printmaking

a vital medium in ways that are inconceivable in the relatively static world of painting and drawing.

Print publishers established themselves early on as purveyors of all kinds of prints — from current events to maps, from original compositions to reproductions of famous works of art, including allegorical series, portraits, and landscapes — which they marketed to broad groups of buyers, from pilgrims and tourists to collectors, craftsmen, and the "common man." In this regard very little has changed in six hundred years of printmaking beyond the limiting of edition sizes. Since the 1960s, for example, artists, master printers, and publishers have made concerted efforts to broaden the market for art produced in printed, or three-dimensional, serial formats. At the same time, multiplicity has become codified within our culture, thus easing the entry of a new generation of collectors of printed matter.

In the hands of artists like Rembrandt (who varied impressions by using different papers and manipulating the inking of individual impressions) or Edward Ruscha (who dispensed with traditional "inks" in many of his editions), the print has also been conceived as a virtually unique object rather than as an endlessly and mechanically repeatable multiple. In tandem with the increasing emphasis on the limited edition, this individualization of the multiple has contributed to the self-conscious notion of the "original print" that has become increasingly predominant in the twentieth century, culminating in the production of very small, highly marketed, collectable editions. Such small productions have the seemingly contradictory effect of making precious something that is, theoretically at least, endlessly repeatable. There have in turn been movements throughout the last century to subvert both this "preciousness" and the rigid divisions of printmaking media for both aesthetic and political purposes. This exhibition provides a fleeting glimpse at the true expanse of these possibilities.

The authors wish to thank Anne Coffin and the Trustees of International Print Center New York for involving us in this inaugural project, as well as the lenders to the exhibition. We thank the following individuals for their time, insight, guidance, and assistance: Richard Axsom, John Baldessari, Mark Baron, Elise Boisanté, Bruce Conner, Susan Dackerman, Lesley Dill, Sidney Felsen, Jay Fisher, Margaret Glover, Virginia Green, Peter Halley, Ellen Handy, Jane Hart, Jon Hendricks, Jean-Nöel Herlin, Susan Inglett, Anne Varick Lauder, Gabriel Landau, Leonard Lehrer, Steven Leiber, Heather Lemonedes, Meg Malloy, Cindy Medley-Buckner, Claes Oldenburg, Nadine Orenstein, Robert Rainwater, Sue Welsh Reed, Edward Ruscha, Max Schumann, Judith Solodkin, Richard Tuttle, Coosje van Bruggen, Roberta Waddell, Lawrence Weiner, and Scott Wilcox.

In addition, the organizers would like to recognize the generous cooperation of the following individuals: Karen Breuer, Mikki Carpenter, Mark Cattanach, Mary Dean, Carol Eckman, Alison Gallup, Melissa Gold, Larissa Goldston, Janet Hicks, John Ittman, Peggy Kaplan, Nancy Press, Jennifer Roberts, Leah Ross, Wendy Weitman, David White, Stephanie Wiles, and Deborah Wye.

HARD PRESSED

600 Years of Prints and Process

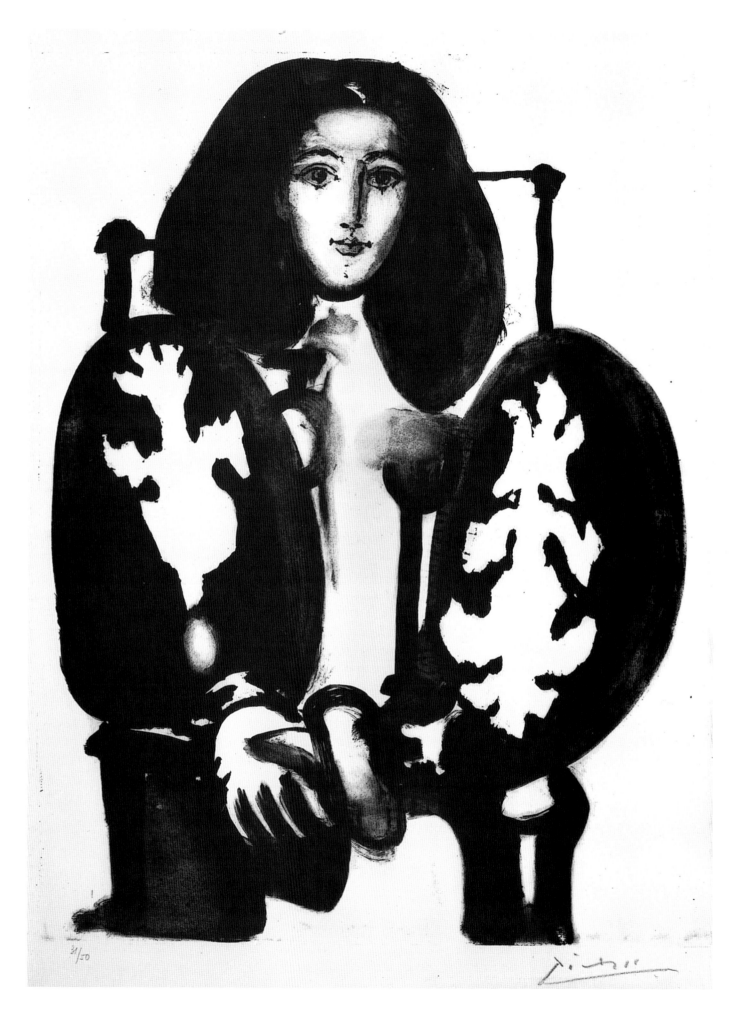

12

Matrix, Mark, Syntax
A Historical View of Printmaking in Relation to Its Techniques

ELIZABETH WYCKOFF

> He listened carefully, then did the opposite of what he had been taught, and it worked. He always proceeded like this whatever he did; the way in which he worked the lithographic stone was not merely contrary to custom, but contrary to the most basic rules of the craft.
>
> Fernand Mourlot on Picasso as a printmaker[1]

1. Quoted in Melot, Griffiths, and Field, *Prints*, 184–85.

Pablo Picasso
74 *Femme au fauteuil no. 1 (Woman in an Armchair No. 1),* 1948–49
Lithograph printed in black, final state (December 30, 1948)
The Museum of Modern Art, New York
Curt Valentin Bequest (361.55)
(See page 69.)

PABLO PICASSO was a prolific and, at his best, an extremely innovative printmaker. His multiplate zinc lithograph *Femme au fauteuil no. 1 (Woman in an Armchair No. 1),* 1948–49 (nos. 74, 75), which began as a single five-color composition printed by Mourlot from five separate color plates, exemplifies his lone-wolf approach to printmaking. Dissatisfied with the initial five-color proof, Picasso went on to make five distinct black-and-white prints, reworking each color plate as many as nine times. For two of the plates (the red and the violet), he reworked the original zinc plate so extensively that Mourlot had to transfer the images to new plates to enable Picasso to continue developing the compositions. The "final" version of the red plate (no. 74) was, according to Mourlot, actually a reworking of a chalk offset from the first state (an impression dusted with red chalk and transferred to a new metal plate). Picasso worked the red plate through three more states following the transfer (no. 75).

The evolution of *Woman in an Armchair* speaks to some of the themes of this essay, including technical innovation and collaboration. The essay's aim is to provide general historical background on the development of printmaking techniques used by artists, highlighting examples of groundbreaking or unusual approaches to new and traditional techniques. It will propose a historical progression of our understanding of the development of printmaking on the one hand, and will also make clear that virtually all of the basic technologies for making prints originated outside the fine arts. Far from comprehensive, this is a highly selective exercise, one that could be repeated in endless variation.

Beginning in the eleventh century, some centuries into the history of the woodcut technique in China, the time line considered here moves through fifteenth-century Europe, with an early use of a wooden matrix to print images on paper in the West, and continues through the first half of the twentieth century.

Early Histories of Prints

History's arbitrary retention and rejection of facts and artifacts makes the story of the origins of printmaking in Western Europe difficult to know completely. The futility of identifying printmaking's precise origins was poetically expressed by the nineteenth-century etcher Ludovic Napoléon Lepic (nos. 52, 53) who, writing about the origins of etching, admitted his own ignorance. It is the "privilege of great inventions," he wrote, "... that they have lost their birth certificates.... Any discovery is a collective work that a man of genius solicits long before anyone else, and that one day another man of genius conclusively articulates for everyone."[2]

2. Lepic, "Gravure à l'eau-forte."

The first histories and manuals of prints and printmaking were just beginning to be written some two hundred years after the appearance of the first European woodcuts. In 1628 the Dutch scholar Pieter Schrijver argued that it was Laurens Jansz Coster, a fifteenth-century resident of his native Haarlem, not Johann Gutenberg of Mainz, who invented the mechanism for printing texts from movable type. Toward the end of his lucid exposition on book printing, Schrijver diverged from his main topic to discuss the printing of pictures. After naming prominent printmakers, including Albrecht Dürer and Ugo da Carpi, he asserted: "This all happened long after the death of our Laurens Coster, to whom, and to no one else, the honor is due for the printing of books as well as plates."[3]

Jean-Michel Papillon, the earliest writer to devote an entire book to the woodcut, in 1766, stressed the ancient origins of the print, citing biblical references: "It was the first of the arts to appear in the world, for if it is true that the children of Seth engraved on stone and bricks, it may be conjectured that they had previously made engravings on wood since it is a softer material."[4]

Even in the mid–twentieth century, Stanley William Hayter insisted upon the antiquity of the basic technology of the print, arguing that engraving, making a groove in a resistant material, predates speech.[5] In his *Sculptura* of 1662, John Evelyn conceded that the invention of "sculpture" was antediluvian, but "the art of engraving and working off, from plates of copper, which we call prints, was not yet appearing, or born with us, till about the year 1490, which was near upon fifty years after T[y]pography."[6] Abraham Bosse, author of the first practical manual for printmakers, published in 1645, stated that "there is no assurance that [engraving] preceded the printing press, because there are no traces like one sees with other types of prints."[7]

It is implausible that these authors were ignorant of early-fifteenth-century woodcuts. Evelyn concentrated on copper plates, but he mentioned printing from woodblocks. Schrijver was an enlightened bibliophile who undoubtedly was familiar with fifteenth-century wood-cuts, many of which survive today only because they were pasted into manuscripts and early printed books. Perhaps these writers were convinced that it must have taken a known artist of large ambition to conceive of producing multiple images from a single matrix. Insistent upon naming their inventors, they pushed aside the often anonymous creators of earlier, less obviously refined prints, and in doing so postdated the printing of images by several decades, erroneously giving priority to the printing of texts.

In the second half of the eighteenth century, historians, beginning in 1752 with Abraham von Humbert, began to acknowledge the origins of printmaking in the woodcut in the decades around 1400.[8] Karl Heinrich von Heinecken wrote in 1771: "It is incontestable that the printing of images on paper by woodcut preceded that of engraving on metal," and in much the same vein he asserted that woodcut images preceded typography.[9] By 1808, when Hendrik Jansen wrote on the subject, the modern understanding of the origins of printmaking was solidly in place. Jansen was willing to acknowledge the anonymous masters as the inventors of both woodcut and engraving, recognizing that unnamed wood-cutters printed the first playing cards in Germany in the second half of the fourteenth century and that engraving was practiced by goldsmiths before it was used by painters.[10]

Early connoisseurs of prints, such as Giorgio Vasari in the sixteenth century and Adam von Bartsch in the nineteenth, emphasized the work of painters who designed and executed their own prints, a prejudice that continues today. In 1803 Bartsch wrote in the preface to his *Peintre graveur:* "Prints executed by authors, that is to say, by the painters themselves, almost always have the advantage over those made by printmakers, that they have nothing in them that is contrary to the ideas of the inventor."[11] Despite this emphasis on the application of printmaking techniques to art, the evidence indicates that all the basic technologies of printmaking originated and were in use outside the fine arts, even if the direct lineage from the various decorative arts to the world of prints is not always traceable. The primary products of the early woodblock appear to have been playing cards and decorated textiles.

3. Schrijver, *Laure-crans Voor Laurens Coster Van Haerlem*, 111–12.

4. Papillon, *Traité historique et pratique de la gravure en bois*, 1: 1.

5. Hayter, *New Ways of Gravure*, 18.

6. Evelyn, *Sculptura*, 35.

7. Bosse, *Traicté des manières de graver en taille douce sur l'airin*, 1.

8. Humbert, *Abrégé historique de l'origine et des progrez de la gravure et des estampes en bois*, 71 ff.

9. Heinecken, *Idée générale d'une collection complète d'estampes*, 235.

10. Jansen, *Essai sur l'origine de la gravure en bois et en taille-douce*, 150 ff.

11. Bartsch, *Peintre graveur*, 1: iii.

Sebald Beham's woodcut wallpaper from the mid-sixteenth century highlights the connections between fine and decorative arts (no. 13). The earliest intaglio prints were by gold- and silversmiths, and Master E. S., Antonio del Pollaiuolo, and Giorgio Ghisi — among many other printmakers throughout the centuries — show evidence of having been trained in goldsmiths' shops.

Similarly, the "discovery" of etching in the early sixteenth century involved the acid baths used by ironworkers to decorate armor and other objects. As with the origins of the woodcut in textile printing, there is no direct evidence that the use of acid to etch lines in metal was passed from ironworkers to the earliest etchers, notably Daniel Hopfer (no. 6), although recipes for the acid were already in circulation before the earliest etchings.

Four hundred years into the history of prints, the invention of an entirely new category of replication — lithography — followed a similar path. Born in a more historically self-conscious age, lithography's origins just before the turn of the nineteenth century were relatively well reported from the start. In a famous episode in the history of prints, the actor, playwright, and inventor of lithography Alois Senefelder came upon a process he termed "chemical printing" by accident while searching for a means to reproduce his plays easily and inexpensively. By then, the art of printmaking — the transfer of an image from an inked matrix onto paper — was fully established and sufficiently sophisticated for lithography to have been immediately adapted to artistic uses (no. 44).

The advantages of lithography include faithfulness to the mark as it is put on the stone as well as the possibility for a larger print run than is practical for the earlier printmaking techniques. Consciously seeking a wider audience for his work, Rodolphe Bresdin, in the 1870s, had eight of his etchings transferred by a printer onto a lithographic stone (nos. 47, 48), creating more widely available editions. The process of making a drawing on specially prepared transfer paper that is then adhered to the stone by the printer (see Arthur B. Davies, no. 56) was adopted by many painters who found working directly on the stone tedious, unresponsive, or otherwise impractical. The loss of exclusivity associated with lithography also brought its detractors, and debates raged on this topic through the nineteenth century, culminating in 1896 with Joseph Pennell's suit against Walter Sickert, who had attacked Pennell's use of transfer paper. Defended by James McNeill Whistler and museum curators, transfer lithography prevailed. Acknowledgment of the hopelessness of this debate came in the catalogue of an 1899 exhibition of Henri Fantin-Latour's transfer lithographs: "Trying to decide what is art and what is process, according to the nature of the crayons or the tool used, has become a Chinese puzzle: you could meander forever in these arguments."[12]

This debate highlights an ongoing problem in the relationship between technology and art, namely that it takes time for a new technique to be accepted as "art." The example of the woodcut is the earliest case in point. A hierarchy of the printmaking media emerges in early mentions of prints, in which the woodcut takes the bottom rung. This was underscored by Vasari, whose *Lives of the Artists* (1568) remains a vital source on Italian Renaissance art and who favored engraving. Vasari gives passing notice to woodcuts, as in his praise of Dürer. But when he mentions Italian borrowing from German prints ("[Italian artists] have since availed themselves of the vast abundance of [Dürer's] beautiful fantasies and inventions"), he is praising the motifs copied by the Italians in engravings, not the woodcut technique itself.[13] In the early sixteenth century, Marcantonio Raimondi, for example, borrowed content but not technique in his infamous engraved copies of Dürer's woodcut *Life of the Virgin* series.[14]

In the mid–nineteenth century, the invention of photographic processes for directly capturing an image of the natural world resulted in rapid, revolutionary changes in the basic conception of the print. Like traditional printmaking techniques, photography allows for a multiple, but it differs fundamentally from woodcut, etching, or lithography. Not only is a photograph a facsimile of the physical world, but its production — the action of light on a chemically prepared surface — involves neither ink nor physical pressure. Changes in

12. Bénédite, *Catalogue des lithographies originales de Henri Fantin-Latour*, 13.

13. Vasari, *Lives*, 6: 94–95.

14. Marcantonio's copies, done in 1506, included the seventeen from Dürer's series (twenty in all, executed between 1502 and 1511) that were completed by then.

the realm of traditional printmaking after the introduction of photography, which was conceptually equivalent to the introduction of woodcut images over five hundred years earlier, and the computer some one hundred years later, occurred in the nature and execution of the techniques themselves and in their functions. As it became possible to reproduce paintings, sculptures, and drawings "verbatim," as it were, the role of the reproductive print, until then the most reliable disseminator of secondary information about other art forms, was in need of revision.

The broad lines of this revision occurred in at least two distinct ways. First, the rapid development of myriad techniques for photographic transfer of designs to the printing matrix revolutionized the printing industry; photography began to be utilized in the production of book illustrations, and its use also encouraged the evolution of illustrated magazines. Second, a reemphasis on the craft of printmaking developed in at least two directions — one, the etching revival, insisted upon the originality of the artist's print, and the other celebrated the old-fashioned craft of the print as a reproduction intended for mass distribution. Reproductive printmaking enjoyed a flurry of activity in American wood engraving, for example in Timothy Cole's phenomenally detailed prints after the old masters (no. 55), but it eventually was overwhelmed by the popularity of photomechanical means of reproduction. On the other hand, the celebration of the craft of printmaking has continued in numerous and divergent forms.

Deep-seated competition persists among the makers of prints; there have always been those who embrace the newest methods and those who reject them for a return to traditional means. Around 1900, artists such as Paul Gauguin and Emil Nolde attempted a return to basics, promoting those aspects of the woodcut that had previously kept it on the margins of art making. For Gauguin, the woodcut created a "primitive" space in which to work that paralleled the subject matter in his paintings and sculpture (no. 54). Among his innovations were the use of unusual tools, some borrowed from lithography, and the printing of his blocks himself in an idiosyncratic manner. In a 1900 letter to Ambroise Vollard, he wrote about a shipment of recent work: "half of [the blocks] were used twice and there is no one but me who is capable of printing in this fashion."[15] He also worked on the harder surface of the woodblock's endgrain, the practice that enables the high degree of detail in wood engraving, but with results like a woodcut. Nolde similarly emphasized the rougher qualities of the woodcut in his experiments with the technique. The barren plank hacked roughly along its natural contours is clearly palpable in *Der Sänger (The Singer), 1911* (no. 63).

Cole, on the other hand, aimed to efface all traces of the woodblock's characteristics. His *Maternité (Motherhood), 1909* (no. 55), which reproduces a painting by Eugène Carrière, is fraught with contradictions. Although he was using a centuries-old technique, he exploited new technology, such as having electrotypes produced from the block for larger editions and for greater fidelity to the original. According to Cole, "printed from the electrotypes, none of [the blocks'] delicate values could be altered."[16] His reproduction of a work by the least linear of painters (Carrière was known for his moody, soft-edged compositions), using the most linear, unyielding of media, is a pictorial paradox.

In the first half of the nineteenth century a number of technical innovations, including the invention of lithography, the use of steel as a more durable replacement for copper, the steel facing of copper plates, and electroplating allowed for much larger print runs. Drypoint, which relies on the richness of the fragile copper residue (burr) along the edge of the lines, is the most delicate of printmaking techniques. Only about a dozen decent impressions can be printed from a drypoint plate, while several hundred impressions are possible from a good engraved plate, and thousands of impressions can be produced from a woodblock under the right circumstances. A copper mezzotint plate, which depends on an overall low-grade burr for depth of tone, will provide fewer good impressions than an engraved one, generally less than 150, but it is estimated that about 1,200 good impressions can be pulled

15. Quoted in Mongan, Kornfeld, and Joachim, *Paul Gauguin*, 203.

16. Letter from Timothy Cole to Frank Weitenkampf, Sept. 24, 1929, New York Public Library, Print Collection, Miriam and Ira D. Wallach Division of Art, Prints and Photographs.

from a steel mezzotint plate. A steel-engraved plate, a lithographic stone, or a zinc plate, however, can produce as many as 20,000 to 30,000 impressions.

The greatest long-term impact of large print runs has been the issue of exclusivity, which climaxed in the nineteenth century with the etching revival and the concept of the limited edition that was conceived and promoted in France by Philippe Burty, a founding member of the Société des Aquafortistes. The canceling of plates, which to Jean-François Millet seemed "a most brutal and barbarous matter,"[17] soon became common practice, ensuring that there would be only a limited number of approved impressions of a single print, as in Whistler's *Little Venice*, 1880 (nos. 49, 50). The hand signing of prints is also a nineteenth-century phenomenon — Whistler charged double for signed impressions of his prints — and the numbering of individual impressions within an edition has become standard only in the last half century.

17. Quoted in Melot, Griffiths, and Field, *Prints*, 111.

Such limiting and documentation heightens a print's marketability, making it more desirable and valuable on account of its greater "originality." This demonstrates how much the capabilities of technology can be skewed for the sake of the market, exemplified by recent tiny editions of three to fifteen Iris prints by Charles Long (no. 145). For the first five hundred years or so of printmaking, prints were widely collected for their artistry and rarity, but there were only sporadic attempts to limit edition sizes. In fact, many plates, including Rembrandt's (after his death), were printed until the lines were nearly gone, then reworked and printed again.

The collaborative relationship among artist, printer, and publisher — or the lack thereof — has from the beginning been an important aspect of printmaking. In early wood-cutting shops, there was a strict division of labor, by which one person designed the image, a second transferred it to the block, a third cut the block, the printer printed it, and finally the illuminator applied color. Nearly all of these aspects of printmaking require technical expertise, making collaboration almost inevitable, but the relationships between artists and technician-craftsmen have been extremely varied. In the sixteenth century the first print publishers began to coordinate the production of wide varieties of prints, but at the same time there were artists who did everything themselves. It is widely believed that Dürer cut his own woodcuts at first but later trained craftsmen to carry out the extensive labor of cutting out the lines of the blocks. In the 1580s Hendrik Goltzius developed an extensive workshop with a coherent style (nos. 18, 19). In the seventeenth century Jan van de Velde II etched and published his own prints (nos. 25, 26), and nearly three hundred years later Gauguin cut and printed his own blocks, but both issued only small editions themselves before passing the work to a professional printer-publisher.

The role of the reproductive engraver, often employed by a publisher, emerged as it became obvious that professionally trained printmakers were better equipped for the business than the painters themselves. But the transformation from an artist's work in one medium to another by a printmaker did not always produce satisfactory results. Bartsch used the language of translation to justify his prejudice for the work of painter-etchers: "like a translation can only be exact when the translator has penetrated the ideas of the author, in the same way a print will never be perfect if the engraver does not have the talent to seize the spirit of the original, and to render the value with the lines of his burin."[18]

18. Bartsch, *Peintre graveur*, 1: iii.

The earliest painter-etchers tended to produce their own plates, although many of them must have enlisted professional expertise and equipment. Even though the majority of painters who made prints did not own a press, the involvement of the artist in the printing process is frequently evident. It is clear just looking at his prints that Rembrandt was intimately involved in the printing process.

Resistance to professional printers was made explicit by Lepic, who discussed his disdain for the tradesmen who apparently exhibited reciprocal feelings toward him. In the 1870s he printed his most ambitious print himself in eighty-five variant impressions, render-

ing a range of atmospheric conditions from rain and snow to moonlight, and altering the features of the landscape (nos. 52, 53):

> Printing my plate of the "Banks of the Escaut River" by myself, I finally realized my dream; I obtained the most varied and contrary effects, which had become impossible since etchings have been printed by workmen instead of by the artist himself. We know that Rembrandt, Ostade, etc., even Norblin more recently, printed their own works. . . . For the true etching, the artist is everything and the workman mustn't even be taken into consideration.[19]

19. Lepic, "Gravure à l'eau-forte."

Discerning professionals like the publisher Alfred Cadart and the printer Auguste Delâtre, however, literally made the etching revival possible, allowing countless artists to make and distribute etchings. The polemic between artists and technicians continues today, as does the endless variety of styles of collaboration. The need for technical expertise often tempers an artist's desire for independence, but in reality the printer is often the catalyst for innovation and not just a facilitator. There have always been artists who prefer to work alone at all costs. Others single-mindedly take advantage of the resources of professionals, and yet others are stimulated and challenged in the first place by the experience of their collaborators.

Relief Printing and Its Origins

When the first woodcuts were printed on paper in Western Europe around 1400, the technology of transferring an image from a wooden matrix to textiles and paper had already been in place in China for several hundred years. A woodblock from the eleventh century, with a combination of Buddhist text and images of Buddha (no. 1), is considered to be the earliest surviving block with a pictorial representation. Several variables coincided to enable the introduction of the woodcut in Europe, including the technology of cutting and printing woodblocks, paper manufacture, and a demand for printed images. The first paper mills were established in Italy and Germany by the 1390s. The earliest documentation of woodcut playing cards is from about 1380, and textile printing had been introduced to Europe by the fourteenth century. Both secular and religious concerns served to create a demand for woodcuts — first, the extreme popularity of the card game, continuing with a vital industry in hand-painted devotional woodcuts and engravings.

Fifteenth-century German woodcuts tend to be matter-of-factly executed outline compositions that served as a base for a brightly hand- or stencil-colored picture, suggesting that they were conceived as inexpensive versions of wall paintings or manuscript illuminations. Although the makers of most of these first-generation woodcuts are unidentified, a *Pietà* now in the Museum of Fine Arts, Boston, is signed by a certain Master Michel of Ulm (no. 2). Dürer's *Apocalypse* series, ca. 1496–98 (nos. 7, 8), changed the rules of the game, giving new autonomy to woodcuts as independent artworks. Italy's woodcut trade picked up in the sixteenth century when a number of remarkable woodcuts associated with Titian were produced. Among these are some of the largest and most impressive woodcuts in the history of art, including *The Submersion of the Pharaoh's Army in the Red Sea*, ca. 1514–15 (no. 15). As David Rosand and Michelangelo Muraro have pointed out, in contrast to the controlled regularity of Dürer's woodcuts, Titian seems to have deliberately emphasized linear irregularity in his drawings for these prints, resulting in shimmering effects in the final product that imitate his looser drawing style.[20]

20. Rosand and Muraro, *Titian and the Venetian Woodcut.*

In the early twentieth century, the ease with which color could be incorporated into relief printing became its most attractive feature. Inspired by French interest in Japanese color woodcuts, many artists used wood- and linocuts as the basis for color printing experiments. Blanche Lazzell is one of many artists who made the pilgrimage to Provincetown, Massachusetts, where the white-line color woodcut was popularized. *My Provincetown Studio*, 1933 (no. 73) — an impression described on the verso as the fifth impression from

that block (no. 72) and the 352nd woodcut she had printed — is, like all Provincetown prints, printed from a single block. Each color is inked separately with watercolor and printed with a spoon or a bowl. Creases in the paper where it is folded around the edge of the block assure proper registration for the successive color printings.

The addition of linoleum to the relief processes is another example of industry serving art. Developed in the 1860s for flooring, linoleum was first used to print wallpaper some thirty years later. By the early twentieth century it was in use by artists as a malleable yet durable printing matrix that could be printed either by hand or in a press. In the early 1930s, Cyril Power, a student of the progressive Grosvenor School in London, utilized the new product to render colorful images of modern life in broad, abstracting forms. *The Tube Train* was printed from four blocks — yellow, blue, green, and red (nos. 64–66).

In contrast, Picasso's 1962 *Nature morte sous la lampe (Still Life by Lamplight)* (no. 76) is printed in yellow, green, red, and black from a single linoleum block. The portion for each color was cut in succession, starting with yellow and ending with black. Picasso's reduction linocuts convey the sense of process as a performance that is at least as compelling as the final product. The differences between Picasso's and Power's linocuts are not just in style and period. Picasso preferred a thick, pasty, opaque ink stamped boldly onto the surface of the wove paper, while Power used transparent color mixtures on a softer, more absorbent sheet, achieving delicate color mixes.

Intaglio: The Authority of Engraving

Some decades following the first appearance of woodcuts in Europe, images began to be printed on paper from a metal matrix. As with woodcuts, the earliest extant examples are playing cards, made in Germany in the 1430s and 1440s. Although the otherwise unidentified Master of the Playing Cards who engraved the earliest intaglio prints appears to have been a painter, most of the other first-generation engravers were gold- and silversmiths. Serving as records for internal shop use or for distribution between workshops, their prints were probably also used as a marketing device.

The work of Master E. S., who developed a pictorially ambitious if not exactly painterly style, displays the characteristics of the goldsmith's craft. There were few printmakers from whom he might have learned, and yet his willingness to carve deeply and surely into the copper and the acute decorative sense indicative of his craft are evident in the platter-shaped *Saint John the Baptist in the Wilderness* (no. 3). Martin Schongauer, the son of a goldsmith, reveals his links to the goldsmith trade in a design for a censer of ca. 1480/90 (no. 5). A French goldsmith, Jean Duvet, reinvented Dürer's *Apocalypse* a half century later with the burin (no. 12). The ambitious self-reference in his portrait of the artist as John the Evangelist is confirmed by the presence of the engraver's burin on the table in front of the seated figure. The connections of intaglio printmakers with the metalworking trades continued throughout the seventeenth and eighteenth centuries. Daniel Kellerthaler, another goldsmith, obtained curious effects in the early seventeenth century using a small, pointed instrument, building up his compositions with a network of dots (no. 20). The effect is of a photographic negative in which the lights and darks are reversed, suggesting that he may have taken impressions from plates that were intended to be decorative plaques.

The intaglio processes are diverse and numerous. The variety of preparations that copper, brass, iron, tin, lead, steel, zinc, and other plates have been exposed to is ample testimony to the versatility of the material. Bartsch, in his *Anleitung zur Kupferstichkunde* (1821), listed eleven distinct types of intaglio processes.[21] Except for works made with iron plates, in which the rusting of the plates quickly caused spots on the plates that also appear in impressions, it is difficult to determine which metal has been used. Until the nineteenth century, copper was generally most prevalent, but exceptions include the use of iron in etching in sixteenth-century Germany and brass for engraving in Italy and elsewhere. A 1481 docu-

21. Bartsch, *Anleitung zur Kupferstichkunde*, 1–2.

19

ment between an Italian painter and engraver specifically indicates that the engraver will supply an engraved "brass plate."[22] The metal referred to in the title of Bosse's 1645 manual for printmakers, "airin," translates as "brass," but in his text he discusses copper.[23] Thus there may be a language problem rather than a real difference in the type of metal used.

22. Landau and Parshall, *Renaissance Print*, 104.

23. Bosse, *Traicté des manières de graver en taille douce sur l'airin.*

The development of engraving began in Italy soon after it took off in the north, and distinct geographical aesthetics developed. In Dürer's north, bold, linear contrasts of dark and light predominated, while in Italy, lighter, silvery, more subtle tonal gradations were prevalent. Differences in ink color — gray in Italy versus black in Germany — as well as in types of metalwork used account for many of the differences. Brass is significantly harder and more resistant than copper; it would not be surprising to find that some of the more stiffly executed fifteenth- and sixteenth-century engravings were on brass.

Pollaiuolo, whose *Battle of the Nudes*, ca. 1470/75 (no. 4), is one of the monuments of European printmaking, was a versatile artist and artisan who worked in many media. *Battle of the Nudes* is his only known print, but he maintained activity as a goldsmith throughout his career. His work as a painter accounts for the ambitious monumentality of the composition of this print, but it was his ease with the tools of the metalsmith that enabled him to execute it on such a large scale.

Diverging from the linear art of the schools of Florence and Rome, in Venice Giulio Campagnola developed a method of stipple engraving that closely approximated the paintings of his Venetian contemporary Giorgione. With his stipple method he could, as in his *Venus Reclining in a Landscape,* ca. 1508–9 (no. 11), render a composition using no linear elements whatsoever; even the delineation of the edge of the cloth on which the figure lies is composed exclusively of tiny dots. His stippling was so delicate that his plates did not stand up to the press for long, and two hundred years went by before a hardier method of stippling was developed.

The major achievement of the sixteenth-century Dutch reproductive engraver Cornelis Cort (no. 17) is to have developed a syntax of long, swelling strokes that shift easily from thick to thin. A very different technique from Campagnola's, it also approximates a painterly space. The density of line, composition, and interpretive thrust in the damascener-engraver Ghisi's *Allegory of Life,* 1561 (no. 16), illustrates the results of a shift toward more complex and painterly subjects and compositions that took place in prints, especially engravings, during the first half of the sixteenth century.

Goltzius (nos. 18, 19) revolutionized the technique of engraving and the business of print publishing. A printmaker's printmaker, at the height of his career he published only works after his own designs. Goltzius spotlighted his skill by creating a series of engravings that emulated the manner of six different artists, including the *Circumcision,* 1594 (no. 19), which was mistaken in its time for the work of Dürer. These *Meesterstukjes* were gymnastic exercises for Goltzius, who was retreating from the bombastic quality of his earlier Mannerist work, such as the *Great Hercules,* 1589 (no. 18). The sheer breadth of his burin work, his inventive originality, and his superlative business skills set an example for subsequent generations of printmakers.

Claude Mellan eschewed crosshatching altogether, developing a virtuosic syntax that used broadly swelling engraved lines, fashioning the composition with parallel lines. His *Sudarium of Saint Veronica,* 1649 (no. 27), consists of a single concentric line that leads from the tip of Christ's nose out to the edges of the veil, and although he picked up the burin more than once in the execution of the "single line," it gives the impression of being as much a performance as Picasso's with his linocuts.

Engraving by itself became rare after the seventeenth century, but even in the twentieth century it has had its practitioners, such as Hayter (no. 82), who combined it with etching, or Jean-Emile Laboureur, a prodigiously spare engraver. Laboureur's meticulous working process is laid bare in the drawing, proofs, and final engraving of his *Asperges et radis (Asparagus and Radishes),* 1928 (nos. 67–71).

The Advent of Etching

As the seventeenth century wore on, painters began to take advantage of etching to make their own prints instead of relying on professional printmakers, whose prints were often too tightly controlled and rigid for the tastes of contemporary painters. Etching, which involves less resistance than the carving involved in an engraving, conveys a looser effect. While scratching a design into the waxy ground coating a copper plate is not exactly like drawing with pen and ink, charcoal, or crayon on a piece of paper, it comes closer than an engraving can. The ability of an etching to resemble a drawing is evident in the work of Parmigianino (no. 14), whom Vasari credited with the invention of etching, though he was born too late for that. In the early seventeenth century, a handful of Dutch painters, including Willem Pietersz Buytewech (no. 22), tried their hands at etching, with sometimes startling results. Their stark landscapes prefigure developments that were made in landscape painting shortly thereafter.

24. Ibid.

Not all etchers aimed for the spontaneous effect of a drawing, however. Bosse, in his 1645 treatise on "the art of engraving by means of acids and hard and soft grounds," extolled past and present etchers for what he saw as their ability to emulate the sculpted swell of an engraved line.[24] His teacher, Jacques Callot, is notable for having standardized a hard etching ground and for his invention of an etching needle called an *échoppe,* which, owing to its oval shape, enabled him to draw a swelling line that closely approximated the line of a burin. Although in their detail Callot's works superficially resemble engravings, their broadly billowing lines caricature the control of engraved lines. His plates, for example the teeming *Fair at Impruneta,* 1620 (no. 24), have a shimmering tonality that is a far cry from the sculptural quality of an engraving. He was able to achieve this effect in part through his practice of multiple bitings, by which the light parts of the composition are exposed to the acid for a shorter time than the dark sections.

25. Sickert, *Down Etching Needle Street*, 235.

26. Bosse and Cochin, *De la manière de graver à l'eau forte*, iii.

Etching is the most versatile of the printmaking techniques. Numerous possibilities and variations have emerged in the five hundred years since Hopfer's adoption of the metal decorating technique. At one end of the range is Karel Dujardin's 1652 *Battlefield* (no. 33), singled out for praise by Sickert in his often venomous essay on etching: "Technically, this plate is perhaps *the* etching of the world. . . . As in Van Dyck, the approaches of the shadows are felt with a sensitive stipple that gives way, at the definite transition into shadow, to expressive line work. Nothing has been left to the printer."[25] Charles Nicolas Cochin's updated version of Bosse's treatise (1745) hints at the technical innovations that followed the original publication. He informed his readers that certain changes had to be made to Bosse's text because "the art of engraving today is completely different from what it was in the time of Mr. Bosse."[26] Among the differences were greater possibilities for achieving tone without linear syntax.

The Introduction of Tone and Color

27. Walpole, *Catalogue of Engravers*, 2n.

"Want of coloring is the capital deficience of prints; yet even this seems attainable," wrote Horace Walpole in 1794.[27] Although the earliest woodcuts were made with the understanding that they would be colored, and this practice has never actually stopped, by 1500 engravers had developed a wide variety of means to produce self-sufficient black-and-white images. The early Italian printmakers' solution to the problem of linear tone was to use closely spaced parallel lines of varying widths, lending their prints a certain smoothness. Dürer's tonal vocabulary of crosshatching became the basic graphic language of printmakers in all media for centuries to follow.

Eventually, the pursuit of smoother tonal effects led artists to seek ways of removing themselves from the constraints of linear alphabets. The development of the chiaroscuro woodcut was the sixteenth century's answer to this concern. In the most dramatic examples, such as Ugo da Carpi's *Diogenes* (no. 10), the use of tone blocks did away with printed lines

almost completely; it also introduced color into the printing process. Although Vasari praised Da Carpi's chiaroscuro woodcuts for "possess[ing] the appearance of having been made with the brush," the technique was only sporadically practiced, and many other experiments followed, with and without color.[28]

28. Vasari, *Lives*, 1: 106.

Etching began to provide greater tonal variety in the seventeenth century, when Callot's multiple applications of the acid bath allowed differentiation in the breadth of lines. A contemporary of Callot, Hercules Pietersz Segers ranks among the most innovative painter-etchers in the history of prints. Long before anyone else imagined making a print that resembled a painting, Segers built up an oeuvre of some fifty etchings, most with printed or hand coloring, often on prepared paper or cloth. *Rocky Landscape* (no. 21) survives in only six impressions, and many of his prints are unique, but his innovation was not only to have treated his prints as individual objects, trimmed and colored at whim. As Egbert Haverkamp-Begemann has hypothesized, he also appears to have used a technique that closely resembles sugar-lift or lift-ground etching, in which the design is drawn onto the plate with ink or another liquid containing dissolved sugar.[29] When the drawing dries, the plate is covered with varnish and washed in warm water; the drawn passages then "lift" off, exposing the copper for etching. This technique was not taken up again until the eighteenth century.

29. Haverkamp-Begemann, *Hercules Segers*, 42–46.

An eighteenth-century Dutch glass painter active in Vienna, Gerhardt Janssen made prints using a technique that resembles Segers's, but like Daniel Kellerthaler's punch engravings, its effect is that of a photographic negative (no. 20). Three of his iron plates survive, suggesting that iron was his metal of choice. The composition appears to have been drawn on the plate with a brush and varnish resist, with refinements scratched into the varnish.

Rembrandt owned one of Segers's plates, but he reworked its surface completely, first in drypoint and then in etching, creating an entirely new image, an action that can only be read as an extreme homage to a master. Already a prolific and able etcher by 1653, when he reworked Segers's plate he transformed its subject from the Old Testament scene of *Tobias and the Angel* into *The Flight into Egypt* (no. 30). Rembrandt is one of few printmakers who can be said to have prefigured Picasso in the radicality of his approach and his willingness to defy the medium. In the early 1650s he took on drypoint; his *Three Crosses* is the most radical manifestation of this experiment. A comparison of the third and fourth states (nos. 28, 29) illustrates the extreme he was willing to go to in the conception of a single composition. By reworking the plate he was also able to salvage a composition that would otherwise have been exhausted after a handful of impressions. Drypoint is a fragile medium owing to the shallowness of the lines made by the needle and the delicacy of the burr, which collects ink and prints indistinctly, creating areas of tone. Few other artists have attempted such a monumental effort in drypoint as this, and it is a testament to Rembrandt's audacity that he succeeded.

Rembrandt's tonal attempts were seldom copied by his contemporaries. The invention of mezzotint during his lifetime partially explains this, but his was also too idiosyncratic an approach for broad application. Prince Rupert, the Bohemian-born cousin of Charles II of England, was the first to develop the technique of mezzotint, in which an image is made by scraping the highlights out of a previously prepared black field, as in *The Standard Bearer*, 1658 (no. 32).[30] Mezzotint, which came into its own in eighteenth-century England, was occasionally combined with etching or engraving, for example in Richard Earlom's *Fruit Piece*, 1781 (no. 40), after Jan van Huysum.

30. Ludwig von Siegen's technique was additive, although it preceded Rupert's by a decade.

The deficiency Walpole saw in prints, namely color, was eliminated, according to Walpole, by "Monsieur Le Blon, who . . . invented coloured prints, and did enough to shew their feasibility."[31] The introduction of color to mezzotint was accomplished in the early decades of the eighteenth century by Jakob Christof Le Blon (no. 36), an enigmatic figure variously described as a genius and a cheat. The development of the process benefited from Le Blon's interpretation and elaboration of Sir Isaac Newton's recent hypotheses on the

31. Walpole, *Catalogue of Engravers*, 2n.

nature of color. After laborious experimentation, Le Blon and others working with him managed presciently to parse the three "primitive," or primary, colors. "In printing them one after the other, combining them like the brush does in a painting," he re-created the optical mixture with which we view the world.[32]

32. Le Blon, "Coloritto," 85.

Cornelis Ploos van Amstel was another experimenter searching for techniques to duplicate color, with an emphasis on drawing (no. 38). His technique consisted first of transferring a drawing to a separate sheet, the back side of which was then coated with a "secret powder."[33] This sheet was then placed on a plate prepared with etching ground and traced through the soft ground, simulating a chalk-drawn line. He would touch the plate up with a roulette, an instrument that creates dotted tone on the plate, and add coloring by hand.

33. Laurentius et al, *Cornelis Ploos van Amstel*, 198, 331.

The English painter Thomas Gainsborough's interest was sparked by the possibilities of soft ground, in which the artist makes his drawing on a sheet of paper placed on top of a plate covered with ground mixed with tallow to keep it from hardening. The pressure of the drawing being made on the paper causes the ground to adhere to the paper, exposing the copper when the paper is lifted off. With the soft-ground technique, the line is transferred in such a way that in texture it approximates both crayon and paper. Hayter (no. 82) and others in the twentieth century have taken up its use again in part because of the ease with which textures — of paper, cloth, wire mesh, and the like — can be transferred to the plate.

Like mezzotint, aquatint is a tonal method, and it has, on occasion, been worked from dark to light, as in Edvard Munch's ethereal *Model in Collar and Hood*, 1897 (no. 61). More commonly, it is executed to look like a watercolor, as in Francisco de Goya's series of eighty etchings and aquatints, *Los Caprichos* of 1799 (no. 42). Goya's use of aquatint in this series is rich and varied, usually in combination with line etching, but in the image of a donkey exhibiting his four-hoofed genealogy included here, and in at least one other plate, he built up the picture in aquatint alone.

34. The Abbé Richard de Saint-Non was a patron, collector, and prolific early aquatinter who collaborated with such contemporaries as Jean-Honoré Fragonard.

Aquatint's origins can be ascribed to three eighteenth-century practitioners: Jean Baptiste Le Prince and the Abbé de Saint-Non in France, and Paul Sandby (no. 39) in England.[34] Sandby, who coined the term *aquatint,* is said to have received Le Prince's recipe from an unnamed English gentleman who had "purchased the secret from him [Le Prince], [and] communicated it to Sandby." Sandby altered Le Prince's dry powder technique (covering the surface of the plate evenly with dry resin powder) by dissolving the resin in "rectified spirits of wine" and applying this spirit ground to the plate in the areas where tone is required.[35]

35. Sandby, *Thomas and Paul Sandby,* 135.

Sandby, already an established watercolorist and etcher at the time, had the necessary background and motivation to work on the new tonal method, and it is likely that his experience in watercolor aided him in the development of the spirit-ground method. The arrival of aquatint was heralded by a number of published treatises on the subject, each of them emphasizing its speed of execution. A certain Monsieur Stapart remarked in 1773 that painters, draftsmen, and printmakers would all find aquatint easier and quicker than making a drawing.[36] Over a century later, in *Liegendes Weib (Reclining Woman),* 1908 (no. 62), Emil Nolde combined aquatint with line etching and other, indefinably smeared passages, like Sandby using aquatint for a washlike tone but with an inkier aesthetic. Nolde thereby calls attention to the etching's presence as a print rather than simulating a watercolor.

36. Stapart, *Art de graver au pinceau.*

In the late 1780s the poet and etcher William Blake, searching for a way to synthesize the publication of his written and pictorial works in the same plate, developed a unique technique for producing etching plates in which both text and image were in relief (no. 43). The details of this technique have long been a source of mystery. In the summer of 1947, the poet Ruthven Todd collaborated with Hayter and Joan Miró in Hayter's New York Atelier 17 in an attempt to reproduce Blake's method. A poem by Todd was written in a solution of asphaltum and resin in benzene on paper coated with gum arabic and soap, after which the paper was laid on a heated plate and run through a press. When the paper was removed, the resist remained on the copper (the text in reverse, ready for printing). Miró then drew

directly on the plate with a brush and an asphaltum solution. The etched plate was then inked and printed as relief, with the surfaces of the letters and drawing inked (no. 78); then as intaglio, with the recesses beneath the design inked (no. 79); and finally as intaglio but with colored inks (no. 80).

A twentieth-century intaglio innovation, the carborundum print was developed by Dox Thrash, working in the Works Progress Administration/Federal Arts Project in Philadelphia. At first, the process was executed in mezzotint or etching, both of which involved the pitting of the surface of the plate by abrading it with carborundum, a gritty mixture of carbon and silicone used to grind lithographic stones. To make a carborundum etching such as Mildred Elfman's *Girl with Flower,* 1938–40 (no. 87), the design is drawn on the pitted surface with an acid resist, and the plate is subjected to an acid bath. It is printed as relief, and both etched and non-etched areas may print; the raised (unetched) areas print darker and the lower pitted surfaces print either as a grainy surface or not at all. Elfman added color to this impression by monotype printing.

Lithography

Lithography, invented in the late 1790s, a few years after Blake devised his process, was the first step in the transformation of printmaking media that exploded with the invention of photography some forty years later. It was the first technique to allow for impressively large runs of prints. The earliest lithographs by artists are pen lithographs, from drawings made with a greasy liquid ink, or tusche, such as Wilhelm Reuter's 1803 *Moses and the Brazen Serpent* (no. 44). Reuter, one of the earliest German artists to make lithographs, was inspired by the first publication of artists' lithographs, *Specimens of Polyautography,* published in England by Philippe André between 1803 and 1807 (the earliest print in that series is dated 1801), which explains Reuter's use of the term "polyautographic drawing" that appears at the bottom of his composition. The crayon technique, in which a grease crayon is used to simulate drawing in pencil or chalk, was also developed early on (and used by Reuter).

Aside from the precocious "polyautographic drawings" by artists in England and Germany, it was the commercial possibilities of lithography that kept the technique alive. Only in the 1820s did lithography begin to develop into a mainstream artistic medium, used by many of the most interesting and challenging artists active in the nineteenth century. Edgar Degas's activity as a printmaker was extensive and probing. His *Mlle Bécat at the Café des Ambassadeurs,* ca. 1877–78 (no. 51), with its enigmatic composition of three separate images, originated as three monotypes that were transferred to the stone while the ink was wet and further refined there.

Much like Degas, Munch did not feel constrained by the technical definitions of the media he chose to work in. The impression of just the black stone of his *Vampire,* 1895 (no. 59), is a remarkably strong-willed image, even without color, with an intense variety of marks, from crayon to tusche with much scraping and scratching. These details are subsumed in the color version, 1895–1902 (no. 60), where the background is created not only with lithographic color but also an additional woodblock for another layer of tone and innovation.

Post-Photographic Techniques

The process of *cliché-verre* is a hybrid of traditional printmaking and photographic processes, in which a drawing is made on a transparent surface (glass), which is then placed on top of a sheet of light-sensitive paper and exposed to the sun, transferring the lines of the drawing to the paper in even tones. Charles-François Daubigny, a painter and etcher who made close to twenty *clichés-verre,* experimented often with different ways of printing. *Sentier dans les blés (Path through Wheat Fields),* 1862 (nos. 45, 46), is shown here printed once with the drawing side of the plate in direct contact with the paper, its clean lines indicating direct trans-

mission, and a second time with the emulsion side of the plate facing up, so that the light, instead of burning directly into the paper, is refracted through the thickness of the glass underneath the drawing, causing a fuzzy, atmospheric look.

The screenprint derived from the decorative arts, specifically sign painting, in the 1870s. The concept of the stencil is of course centuries old (early woodcuts were often colored using stencils), but in screenprinting the stencil is applied to a mesh surface through which the ink is forced with a squeegee or rubber blade. Like carborundum etching, the screenprint's application to the fine arts was much encouraged by the Works Progress Administration. Anthony Velonis, who was assigned in 1938 to an experimental graphic workshop in the New York City Federal Arts Project, was, along with others, responsible for the adaptation and spread of the technique among artists attached to the WPA, such as Hananiah Harari (no. 86), who was one of the first artists to learn the technique from Velonis.

The interactions of artists, printmakers, and printers with techniques new and old, artisanal, artistic, and industrial, have been the fuel with which the history of printmaking has proceeded through the centuries. From the beginning, the collaboration between an artist-printmaker, with ideas and motivation, and a printer, with equipment, skills, and experience — as well as often a publisher to coordinate the process and market the final product — has driven the growth of printmaking. At the same time, the most intriguing and challenging developments have often derived from the decorative arts. The concentration in this essay on artistic interpretations of the techniques as they have been adapted is not arbitrary. Some of the most compelling images in the history of art came about precisely because of the dialogue between the arts and the practical world: Le Blon tackled Newton's new theories, Daniel Hopfer adopted methods that were also being used by armor makers, and Pollaiuolo divided his artistic talents among painting, goldsmithing, and, at least once, printmaking. Master E. S., Schongauer, Dürer, Duvet, Ghisi, Janssen, and many others like them also bridged the gap between metalsmithing and the pictorial arts through their own heritage, practice, and training.

Reconsidering the Fine Art Print
in the Age of Mechanical Reproduction

DAVID PLATZKER

1. See a history of ULAE in Sparks, *Universal Limited Art Editions,* and of Tamarind in *Tamarind: From Los Angeles to Albuquerque.*

2. See Varnedoe, *A Fine Disregard,* for a further definition of the phrase.

Bruce Conner
110 *THUMBPRINT,* 1965
Lithograph
The University of New Mexico
Art Museum, Albuquerque
Gift of Mr. Edward H. Weiss
(See pages 92–93.)

3. As told the author by Conner in telephone conversations, Oct. 1999.

4. These limitations were later changed when the program became a division of the University of New Mexico in Albuquerque.

5. Shortly after making this print, only a few weeks into his stay at the workshop, Conner was asked by the management to terminate his visit.

IF THE recent history of print workshops in America were to be chronicled, it would be clear that many of these workshops were based upon models of European tradition. Beginning with the founding of Tatyana Grosman's Universal Limited Art Editions (ULAE) in 1957 and of June Wayne's Tamarind Lithography Workshop in 1960,[1] a multitude of enterprises followed, founded by printers trained under Grosman and Wayne. But this is a simplistic model of history, for the facts are far more complex. For example, if one were to consider child psychology in relation to the ideals fostered by the strong influences of Grosman and Wayne — whose authoritarian temperaments were legendary — one would see that the trajectory of Grosman's and Wayne's offspring would form a rebellious lineage that would be as complex as the whorl of a fingerprint. The examination of a single variable would fail to yield a complete picture. Similarly, if one were to consider the different uses of technology alone as explanation for the development of printmaking, there would be a corresponding failure to discuss artistic temperament and the *fine disregard* of tradition by many artists.[2] Artists' attitudes toward printmaking, as well as their abilities to use printmaking technologies in ways that are both visually interesting and that expand the boundaries of acceptability, are considered in this essay to be at least as important as the availability of the technologies themselves.

An important example of attitudes toward printmaking in the later half of twentieth-century America, and in particular toward technology within printmaking activities, is Bruce Conner's *THUMBPRINT* of 1965 (no. 110). When Conner, the Beat artist from San Francisco, was invited for a two-month artist-in-residence at Tamarind, he arrived at the Los Angeles workshop with a good deal of printmaking background. He looked forward to using his intensive time at the workshop to hone his skills and produce a large body of new work, but Conner soon found himself feeling "oppressed" by what he perceived to be a "claustrophobic" approach to making art at Tamarind and by the limitations placed on him by the workshop's management.[3] Conner was told that he could not use photographic processes and that he would be required to stick to the nonmechanical reproductive methods that were championed by the workshop as part of their mandate to establish a master printer training program based on the tradition of French fine art print shops.[4] Conner saw these limitations as an affront to his artistic identity, and they inspired him to seek out a subversive approach to both printmaking and the institution of the "master printer." Working within Tamarind's technological constraints, Conner requested the workshop's largest lithographic stone. After having the surface painstakingly prepared, he applied his tusche-coated thumb to the vast surface of the stone and asked for an edition to be pulled. Perhaps in the canon of contemporary art clichés, putting one's finger down (or sticking it out) is both too literal and obvious a reading of this image. Clearly Conner wished to assert his unique identity as an artist in an environment where his artistic choices had become limited, and in *THUMBPRINT* he placed his most personal of signifiers down, plainly, for all to see.[5]

Today this act might be seen as mundane, even sophomoric, but in the mid-1960s it placed Conner alongside a number of other artists, including Richard Hamilton, Claes Oldenburg, Robert Rauschenberg, and Andy Warhol, who were subverting the fine art print in various ways. Conner's *THUMBPRINT* definitively challenged accepted criteria

in printmaking by allowing an artist's slovenly fingerprints to be reproduced in a print, and by using such uncomplicated technology in the process of making the impression. Indeed, the very act of making a fingerprint — an *edition* of fingerprints at that — through the intensive process of lithography challenged the conventions of printmaking in general. Conner's action, his finger hitting stone, begs the viewer to look beyond the formal presentation of the fine art print and contemplate the conceptual frontiers offered by printmaking.

While many aspects of art making are seen as isolated creative activities that take place alone in the studio, working in a professional workshop to make prints is not a solitary pursuit. The artist often works with a master printer, print technicians, and assistants, and perhaps a publisher supervising the process just a stone's throw away. In such situations artists may turn to these professionals for guidance, inspiration, or motivation and the act of printmaking often becomes a performative activity with prescribed actions for each individual.[6] Yet the artist might also choose to work against the grain of traditional approaches, mixing media or inventing new ones. Artists such as Conner represent a vibrant and diverse group whose inclination is often to challenge, or *subvert*, all that has come to represent traditional technique and connoisseurship of the "fine art print."

This is not to suggest that there was a cessation of innovation in more traditional contemporary printmaking. From the early 1960s on, Richard Diebenkorn, David Hockney, and Jasper Johns elevated printmaking to new heights, as Henri Matisse, Joan Miró, and Pablo Picasso had done before them. The concept of "subversion" should be considered as the utilization of traditional and industrial media to yield prints that catalyze new, potentially radical approaches. It should not always be considered as deliberate or aggressive, since subversive activity often comes out of naiveté about what is possible or what is expected. Clearly Conner was not alone in his desire to pursue printmaking outside the boundaries of tradition. Joseph Beuys was equally complicit in taking on the fine art print establishment with his editions of multiples containing printed elements, such as *Das Schweigen (The Silence)*, 1973 (no. 88), and *American Hare Sugar*, 1974 (no. 89). Artists like Conner and Beuys had their own ends in mind and chose to lay waste the anachronistic phrase "fine art print."

An equally provocative example of an artist radically rethinking the possibilities of printmaking, with an eye in particular toward art in the age of commercially available mechanical reproduction, is Marcel Duchamp's self-published *Boite-en-valise (Box in a Valise)*, 1941 (no. 77). This insurgent work announces one of the most clever and elegant jaunts into virgin territories of contemporary printmaking. The genius of Duchamp, and in particular this edition, lies in how the work metaphorically folds back into itself and into the artist's oeuvre. In one sense the project is a three-dimensional postcard rack containing Duchamp's entire artistic output in miniature. Paintings, sculptures, and drawings are rendered in photographic offset or sculpted in miniature and skillfully packaged for ready transport. When the valise is opened and unfolded in pop-up style, the artist's catalogue raisonné is laid bare. This portable museum signaled multifold departures from traditional printmaking that find far greater correspondence to printed artworks produced later in the century than any that came before. The understanding that a print need not be a flat sheet of paper suitable for framing is only one of its many revelations. Duchamp also flipped the conceptual edge of his ready-mades by turning some into multiples, and in doing so he returned the commercial trade goods, which he had anointed as unique art objects, back into serialized replicas.

The *Boite-en-valise* echoed throughout the latter portion of the century, particularly in the medium of the contemporary artist's book. As a subgenre of printed editions, the artist's book, such as Edward Ruscha's self-published *Twentysix Gasoline Stations*, 1963 (no. 116), is said to be the most democratic of all art forms.[7] By taking the European tradition of the *livre illustré* and making it widely accessible, Ruscha rejected the notion of the precious limited edition. Although contemporary *livres de luxe* are still being produced in small limited editions, artists' books are often produced in editions of five hundred copies or more, and they are presented unsigned and unnumbered at a modest cost. By means of these publications, such artists as

6. "Performative" is defined as "an expression that serves to effect a transaction or that constitutes the performance of the specified act by virtue of its utterance." See *Webster's New College Dictionary* (Springfield, Mass.: G. & C. Merriam Company, 1980).

7. See Clive Phillpot's essay in Lauf and Phillpot, *Artists/ Author*. See also Phillpot's essay in Engberg and Phillpot, *Edward Ruscha*, and Moeglin-Delcroix, *Esthétique du livre d'artiste*.

John Baldessari, Daniel Buren, Sol LeWitt, Dieter Roth, and Lawrence Weiner have been able to maximize the possibilities of public access and ownership of their artistic output. Utopian in conception, artists' books were intended to widen the boundary between unique artistic activities — such as painting and drawing — and the printed edition. A subtle ridicule of the limitation of accessibility of precious limited edition artworks is sensed in these publications. They are meant to be handled (not sealed under glass), read, and possibly even disposed of casually. While these publications signaled a change in artistic creation and consumption, the *livre de luxe* has also thrived through innovative projects such as Buckminster Fuller's *Tetrascroll*, 1975–77 (no. 81). As with much of Fuller's work, *Tetrascroll* is an expansive exercise, here seen in the format of a large book (35½ × 35½ × 35½ inches). Comprised of twenty-one lithographs with text and twenty-six triangular sections hinged to form a single, continuous presentation, the book is hard, if not impossible, to lift, let alone discard, and serves to expand upon as well as challenge traditional models of the *livre de luxe* and printmaking.

Artists' books have been produced by many artistic movements — Dada, Pop, Minimalism, Conceptualism, for example — each with differing aesthetic and political ends in mind. LeWitt's and Weiner's publications set the tone for artworks that mirror the trajectory of the artist's work at large and act as self-contained vessels encompassing the particular artist's interests. In an artist's book, intersections between artistic creation, presentation, and viewership can be compressed. Damien Hirst's 1997 feature-rich book *I Want to Spend the Rest of My Life Everywhere, with Everyone, One to One, Always, Forever, Now* (no. 149) is a fine example. Presented as an artist-conceived catalogue raisonné (not unlike Duchamp's *Boite)*, as well as a documentation of critical reviews of the artist's work — including hate mail — it contains numerous pop-ups, pull-downs, foldouts, acetate overlays, and adhesive stickers. All of these elements push the printed edition beyond what is usual in a self-propelled artist's publication. Printing technologies have become so accessible and affordable that books like Hirst's can be produced inexpensively in large quantities. Thus, artists' books have become highly viable commercial objects. As Weiner put forward, in an artist's book one can "learn to read art."[8]

8. See Schwarz, *Lawrence Weiner.*

With the emergence of artists' book and the rise of contemporary print workshops (and print publishers), the healthy art market of the 1960s fueled the possibilities for artists to broaden their audiences through the distribution of prints. Assumed by this acceptance of prints in the marketplace was the idea that a print could be a very different work of art from a painting or drawing. From the artist's perspective, it was recognized that various print media offered unique possibilities, and again, many artists chose to utilize the opportunities afforded them in professional workshops to undermine the traditional practices and expectations of the "fine art print." One of the strong traits of contemporary printmaking has been the willingness of artists and printers to jointly explore not just the boundaries of a particular printmaking medium, but the possibilities of literally throwing everything available at a print edition. This has materialized in the amalgam of strong-willed artists and master printers inventing new media and techniques to fit specific needs as they arise in the creative process.

In many situations, artists and printers have turned to commercial manufacturing technologies to craft something wholly unseen before in artistic activity — either in printmaking or in unique works. Oldenburg's 1969 *Profile Airflow* (no. 102) drove Kenneth Tyler, then the master printer at Gemini G.E.L., to aggressively explore technologies far beyond those found in a traditional printwork. Oldenburg's desire to create a large-scale multiple with a surface "clear in color, transparent like a swimming pool but with a consistency like flesh" was realized with Tyler's experiments with toxic polyurethane.[9] Presented as a cast-polyurethane relief mounted over a traditional lithograph on paper, this edition fully satisfied the artist's conception.

9. Oldenburg in *Claes Oldenburg: Multiples in Retrospect.*

While it is romantic to think of the artist as a creative misanthrope — an aggressive interloper in the print workshop whose primary mission is to complicate the lives of those

around him or her — the reality is that this is rarely the case. Usually the print shop is a social environment where give-and-take is both anticipated and expected. Printmaking is an exacting and redundant process that can take weeks of work and proofing before the BAT *(bon à tirer)* is signed by the artist to indicate that edition printing may begin. The grind of this activity can become numbing, and it is not surprising that many printers seek the challenge of interacting with artists who are working in new and unexpected ways.

Perhaps no artist of the last forty years has been as aggressive about exploring possibilities and challenging printers as Rauschenberg. In all of his projects at Gemini G.E.L. he realized groundbreaking prints and multiples with printed elements that classical fine art print terminology falls short of describing. These editions run the spectrum of unusual techniques and materials: from the life-size lithograph and screenprint titled *Booster*, 1967 (no. 94), which features X-rays of the artist's skeleton, to the complex abstract simulations of corrugated cardboard assemblages that function as sculptures. Not only does *Booster* play out the mechanical usage of photographic lithography, the use of transfer techniques, and issues of physical scale, it also mixes media — both lithography and screenprinting were involved — which was considered wholly unacceptable by print purists at the time of publication. In *Cardbird Box 1*, 1971 (no. 95), Rauschenberg took a found object, a transitory and ephemeral battered cardboard shipping box, and asked that the workshop match it as closely as possible. The resulting Gemini edition is both an illusion of a cardboard box and an actual box realized through multiple runs at the press with a particular technical bravado. It arrives at a visual subversion that is related to Conner's thumbprint and at a level of simulation that puts a twist on Duchamp's ready-mades.

The play of surrogates and artistic doppelgängers is ripe in all of Rauschenberg's work, and clearly there is also an autobiographical layering in much of his imagery. These references become activated in endless variations in *Shades*, 1964 (no. 93), which consists of six planes of plexiglass that can be shuffled, and in *Sling Shots Lit #5*, 1985 (no. 96), which utilizes translucent vertical blinds that can be raised and lowered to allow visual change and recombination of the artist's vast personal iconography.

The freedom to innovate across media is one of the strongest hallmarks of contemporary, if not modern, artistic practice. Given its history from Georges Braque and Picasso's pioneering *papiers collés* of 1912,[10] the notion of mixing etching, lithography, woodblock, offset, screenprinting, handmade paper, and other media within a single printed edition came relatively late to the refined world of the fine art print. Technology played no small role in allowing such artists as Frank Stella, Richard Tuttle, and Terry Winters the liberty to combine all the techniques available to them in creating their highly original works. Stella's *Circuits* series of 1982 (nos. 113, 114) and *Egyplosis Relief* of 1996 (no. 115), produced in collaboration with Kenneth Tyler, take techniques and creativity in printmaking to new heights, widths, and depths. Tuttle and Winters, with a certain modesty, utilized their access to a variety of technologies to create layered works in tandem with their sculptural and painterly interests, respectively.

Innovation has not been limited to new technologies or recombinant efforts with old ones, for in some cases old techniques have become reenergized. Chuck Close's mezzotint *Trial Proof for Keith*, 1972 (no. 121), should be seen as a foremost attempt to recapture the classic elegance of this demanding technique. Later, with editions such as *Self-Portrait Manipulated*, 1982 (no. 122), and *Georgia/Fingerprint (State II)*, 1985 (no. 123), Close began a playful exploration of nontraditional approaches to media and papermaking.

As part of a project initiated by Kathan Brown, Crown Point Press invited artists to have their watercolors rendered by a Japanese master printer in the tradition of *ukiyo-e* woodblock prints. One of these prints, for example, Francesco Clemente's 1984 edition titled *Untitled (Self-Portrait)* (no. 138), was printed from blocks cut by Japanese master craftsmen from the artist's original watercolor in an edition of two hundred. When the prints were

10. See Rubin, *Picasso and Braque.*

issued, the combination of ancient process with new imagery inspired critical comment and discussion about the difference between an "original" print and a skillful reproduction.

Other artists, such as Warhol, took on what had been considered commercial processes, such as photo-screenprinting, to make both unique and editioned artworks. Warhol's surrogate *Brillo Boxes,* 1964 (no. 100), mirrors the mercantile world and serves as a primary example of a unique piece that also functions as an edition. Warhol realized that a single Brillo box would not be so effective a parody of the classical supermarket item usually seen en masse at the local store, and he recognized that an actual Brillo box, a three-dimensional object, was less interestingly rendered as a two-dimensional print in a picture frame than as a sculptural object. Thus Warhol had his simplified Brillo design screened onto oversized primed wooden boxes, thereby taking printmaking into a new dimension. His stratagem of mixing a traditional commercial process with appropriate artistic content brilliantly melded his Pop iconography into this print realization.

Evolving from the concept and aesthetic of the artist's book, artists looked to other types of printed formats in hopes of reaching an expanding audience with their ideas. Masterminded by George Maciunas, collaborative Fluxus editions such as *Fluxkit,* 1964–ca. 1966 (no. 146), *Fluxus 1,* ca. 1964–76 (no. 147), and *Flux Year Box 2,* 1968–77 (no. 148) were produced. These innovative artistic efforts were assembled as boxed, serial, self-contained art items that occasionally compiled ready-made or found objects. These projects walked the line between being serious artworks and parodies of consumer culture. In other instances fine china and paper plates were printed with designs by Roy Lichtenstein; Warhol designed shopping bags; Robert Indiana's *LOVE* logo became ubiquitous as a United States postage stamp; and Johns's do-it-yourself *Target* (no. 105) was issued in an edition of over twenty thousand copies by the Museum of Modern Art as part of its 1971 *Techniques and Creativity: Gemini G.E.L.* exhibition catalogue.

Other hybrid formats, some low priced, sprung up as well. A prime example is William Copley's journal of original printed multiples, titled *SMS* (see nos. 91, 111, 129). Composed of six issues published in 1968, it ambitiously encompasses a wide cross section of artists and media. The contents of *SMS* ranged from a 45-rpm record by Duchamp, a diary of imaginary menus by Oldenburg, and an instruction multiple by Yoko Ono. Presented largely as offset-printed items, *SMS* allowed experimentation with few — if any — limitations, and the mix of artistic styles and generations provided a broad encapsulation of works within the arc of a highly disseminatable format.

In the late 1980s and throughout the 1990s, Felix Gonzalez-Torres's paper stack "sculptures" (no. 144) offered a unique take on the concept of ownership of printed artworks. Comprised of identically printed posterlike sheets, these nine-inch-high sculptures/prints mimic in look the cool minimal aesthetic of Carl Andre, Donald Judd, and Robert Morris. Importantly, these "sculptures" offered a new opportunity for collectors by inviting the viewers to freely remove single sheets for their personal collections. In doing so, the artist also created a direct and symbolic analogy to the temporal existence of departed loved ones — the subtext being that even work within a museum's "permanent" collection may have only a fleeting life, and that what one takes away is a reverberation of something far greater.

Printmaking has provided artists with fertile ground for further exploration of ideas and concepts borrowed from other media. Baldessari, working with Jean Milant at Cirrus Editions, produced the multipart lithograph *Fallen Easel,* 1988 (no. 109), which aggressively breaks convention with its span of nine individually framed and unframed elements. Richard Serra's assertive large prints, such as *Double Black,* 1990 (no. 120), easily fit into the rhythm of his sculptural work and extend the possibilities of printed surface and scale. Chris Burden turned his 1977 printmaking venture at Crown Point Press into a hands-off performative activity by asking the workshop to print a counterfeit Italian ten-thousand-lira note. His *Diecimila* (no. 131) tested the workshop's ability to match every element of the currency:

the seven colors of the government printing, the fine details of the design, as well as the watermark.

Louise Bourgeois's freewheeling sculptural lithograph *Henriette,* 1998 (no. 83), and Mixografia print *Crochet I,* 1998 (no. 84), mark further departures from the conventional use of media. Likewise, Lesley Dill, in her *Poetic Body* series of work from 1992 (nos. 134–37), led Landfall Press, Solo Impression, and Graphics Studio into explorations of sculptured printmaking by incorporating sewn handmade papers and recombining new and conventional elements in a surprising mix. And Christian Marclay's recent use of vinyl records as "plates" to make monoprints (no. 143) casts printmaking as one of the most elemental activities by recognizing that any grooved surface with the capacity to carry ink can, in effect, become a printing surface.

Since the late 1960s, computer and digital technologies have held particular fascination for artists, beginning with simple ray tracing and line plotting, and continuing when artists were granted access to investigate the potential of large mainframe computers as tools in creating art. Much like the advent of the printing press, the computer, for some, represents the next frontier of art making. Yet up until the 1990s the computer proved to be an elusive aid to creativity. The problem lay in accessibility and affordability of hardware, combined with the shortage of available software and skills needed to use and program systems suitable for making art. When computers began to enter artists' studios for word processing, however, the first barrier was overcome, and with the advent of high-quality consumer software like Adobe's Photoshop and Illustrator programs, artists became not only intrigued, but also enabled. There was of course a final barrier to overcome in regard to printmaking — getting what was being presented on the computer screen into a stable print format.

Peter Halley circumvented this obstacle in his 1993 *Superdream Mutation* (no. 140) by having it issued solely as a GIF (Graphic Interchange Format) computer file by the New York City bulletin board system known as The Thing.[11] Halley's artwork could be viewed on any desktop computer running DOS, Windows, or Macintosh (and other) operating software. *Superdream Mutation* is a monochrome image that was sold through The Thing before Netscape and the World Wide Web existed. Local users could dial directly into The Thing and engage in ideologues, roundtable discussions, and diatribes among a small community of artists, writers, curators, and collectors. Halley's work, which was offered for twenty dollars, was possibly the first artwork created expressly for, and exclusively available for, on-line sale and viewing. *Jesus Built My Hot Rod,* produced by Ronald Jones in 1992 (no. 139), took a more complex and somewhat traditional approach to bridging the schism between the computer screen and physical output. Jones, working with publishers Stephania Serena and Charles Warren, output his computer files as a film negative that was then utilized to produce a traditional gravure etching plate for editioning.

With the availability of Iris printers at many local reprographic shops, artists began to have access to high quality output equipment. Founded in 1995, Muse [X] appeared in Los Angeles as a particularly aggressive publisher and promoter of the new medium. One of the obligations yet to be satisfied by digital media, however, is to prove that it can provide artists with tools that produce not only engaging art but artworks that are more than simply prints produced by a particular process with an artificial limitation placed on the edition size, since the physical limitations of the medium are limitless. Published by Muse [X] Editions, Charles Long's portfolio *The Internalized Page Project,* 1998 (no. 145), begins to offer hints as to the future of this form of "post-studio" printmaking in which a new colloboration of art and technology may be melded.

Transgressive printmaking, a radical departure from subversive printmaking activities, is an unbounded area for exploration. Dieter Roth's books and editions use everything available in and out of the print shop to cement his works. In *Literaturwürst (Literature Sausage),* 1961–70 (no. 107), Roth minced books and other preexisting printed materials; mixed them

11. The Thing BBS (Bulletin Board System) itself was an artwork in the form of a Beuysian social structure. Founded in 1991 by Wolfgang Staehle, The Thing today exists as a nonprofit on-line web community located at bbs.thing.net.

with water, lard, gelatin, and spices; and encased the seasoned mixture within sausage skin. John Cage used smoke and fire at Crown Point Press to establish a printing surface in his *Dramatic Fire* and *Empty Fire* editions of 1989 (no. 85). And Ruscha used a myriad of utterly antiestablishment visceral liquids — notably Listerine, nail polish, chocolate syrup, spinach, coffee, mustard, Worcestershire sauce, motor oil, and "blood of the artist" — as the "ink" for his 1969 portfolio titled *Stains* (no. 118), as well as in other of his screenprinted editions.

Even more radical printmaking approaches have been investigated by the Swiss American artist Not Vital. Working with publishers Baron/Boisanté and printers Harlan & Weaver in his edition *Kiss,* 1996 (no. 132), Vital found a genuinely unique approach to aquatint. He took two freshly killed lambs purchased in New York City's meatpacking district into the workshop and coated the lambs' wool with a lift-ground solution, then arranged the mortal remains of the animals into a "kissing" pose directly on a copper plate to create his printing surface.

Printing techniques have evolved alongside advances in technology, while other art forms, in particular painting and drawing, have been relatively static in terms of media. Linseed oil and pigment paints on canvas have faced no genuine innovations in comparison to the inventions found in woodblock, etching, lithography, photography, and digital technologies. In the hands of an inspired artist, the possibilities offered by the various media are boundless and will remain so as long as new technologies are presented and old ones are reinvented, as long as there is a desire to push the edge of limitations.

Anonymous
(Chinese, 11th century)
1 Buddhist sutra with representation of Amida, n.d.
Woodblock; 4⅝ × 17⅛
Spencer Collection
The New York Public Library, Astor, Lenox and Tilden Foundations

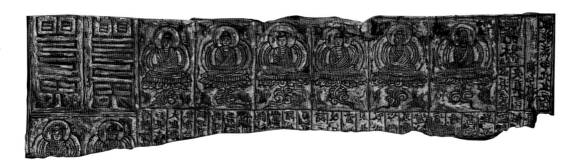

Master Michel
(German, 15th century)
2 *Pietà*, ca. 1460–70
Hand-colored woodcut;
14¹⁵⁄₁₆ × 10¹⁵⁄₁₆
Courtesy, Museum of Fine Arts, Boston. Reproduced with permission
William Francis Warden Fund
(53.359)
© 2000 Museum of Fine Arts, Boston. All rights reserved

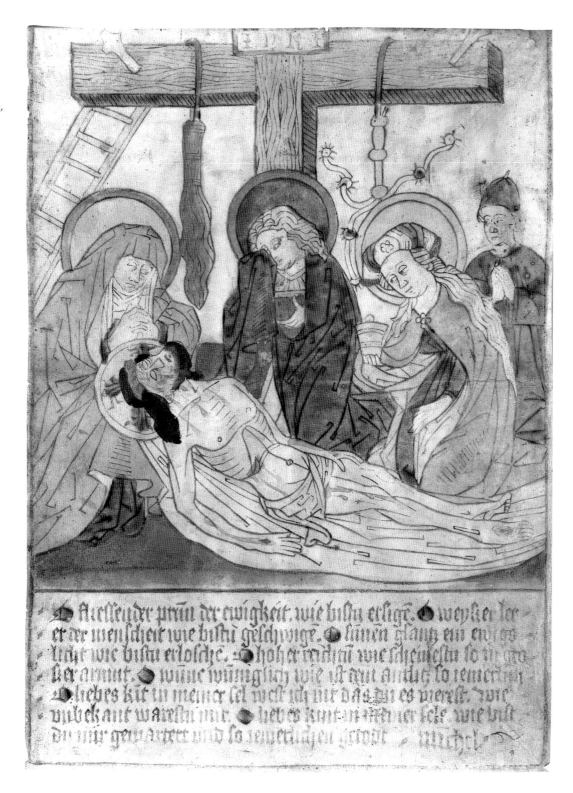

Master E. S.
(German, ca. 1420–1467/68,
active 1440–68)
3 *Saint John the Baptist in the Wilderness,* n.d.
Engraving; diameter 7⁵/₁₆
Courtesy, Museum of Fine Arts, Boston. Reproduced with permission
Maria Antoinette Evans Fund (31.1208)

Antonio del Pollaiuolo
(Italian, ca. 1431–1498)
4 *Battle of the Nudes,* ca. 1470/75
Engraving; sheet 16¹³/₁₆ × 24⁵/₁₆
National Gallery of Art, Washington, D.C.
Gift of W. G. Russell Allen (1941.1.16)

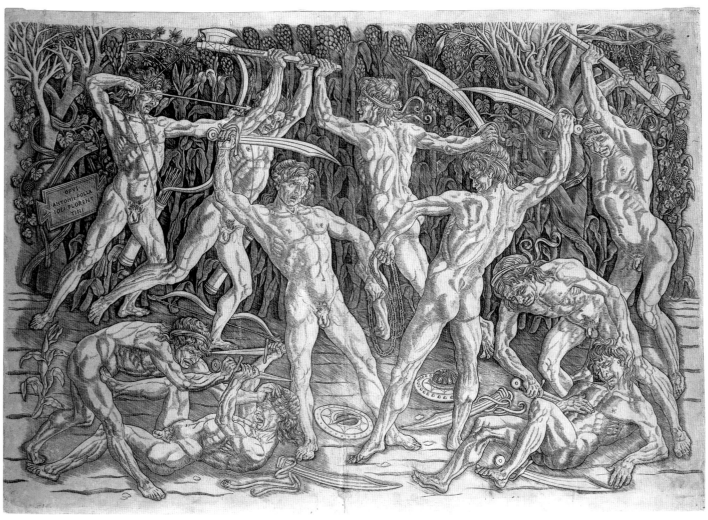

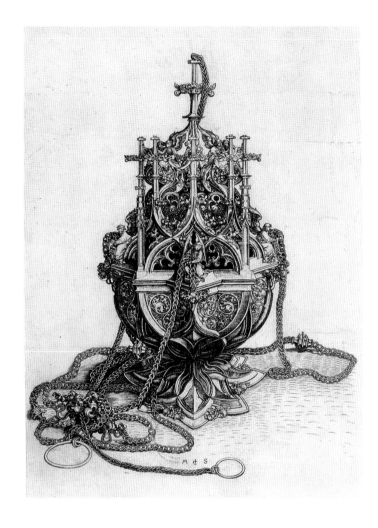

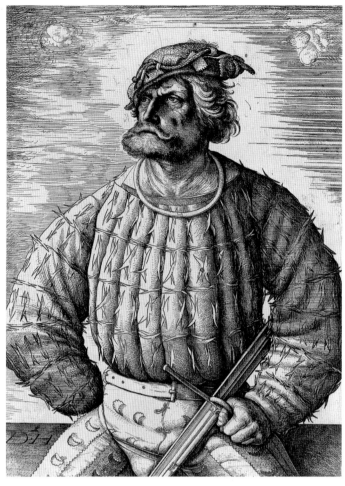

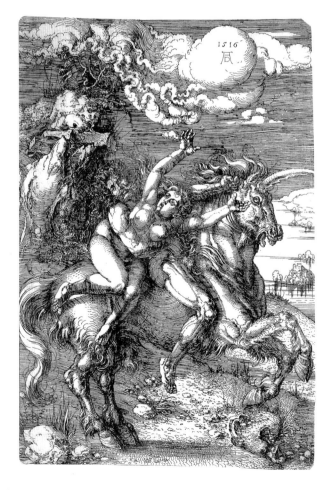

Martin Schongauer
(German, ca. 1450–1491)
5 *A Censer*, ca. 1480/90
Engraving; 12⁵⁄₁₆ × 8⅜
National Gallery of Art,
Washington, D.C.
Rosenwald Collection
(1943.3.89)
Photograph © 2000 Board of
Trustees, National Gallery of
Art, Washington

Daniel Hopfer
(German, 1470–1536)
6 *Kunz von der Rosen*, ca. 1515
Etching; 11½ × 8⁷⁄₁₆
The Frances Lehman Loeb
Art Center, Vassar College,
Poughkeepsie, New York
Gift of Mrs. Felix Warburg and
her children (1941.1.52)

Albrecht Dürer
(German, 1471–1528)
9 *The Abduction of Proserpine*,
1516
Etching; 12⅛ × 8⅜
Collection of Dr. Harris Schrank
Photo: Lisa Martin

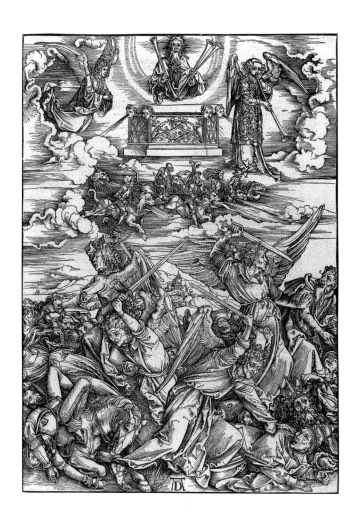

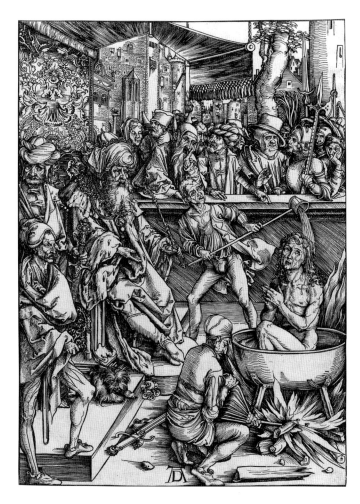

Albrecht Dürer

7 *The Four Avenging Angels of the Apocalypse,* from the *Apocalypse* series, probably 1496 (upper section) and 1497–98
Woodcut; 15½ × 11⅛
Courtesy, Museum of Fine Arts, Boston. Reproduced with permission
Gift of Edward P. Warren (M9412)

8 *The Martyrdom of Saint John the Evangelist,* from the *Apocalypse* series, probably 1498
Woodcut; 15⅜ × 10¹¹/₁₆
Courtesy, Museum of Fine Arts, Boston. Reproduced with permission
Bequest of Francis Bullard, 1913 (M24883)

Ugo da Carpi
(Italian, ca. 1479/80–1532),
after Parmigianino (Italian,
1503–1540)
10 *Diogenes*, n.d.
Woodcut, chiaroscuro in
four blocks; 18¹¹⁄₁₆ × 13⅝
The Metropolitan Museum
of Art, New York
Purchase, Joseph Pulitzer
Bequest, 1917 (17.50.1)
© 1999 The Metropolitan
Museum of Art

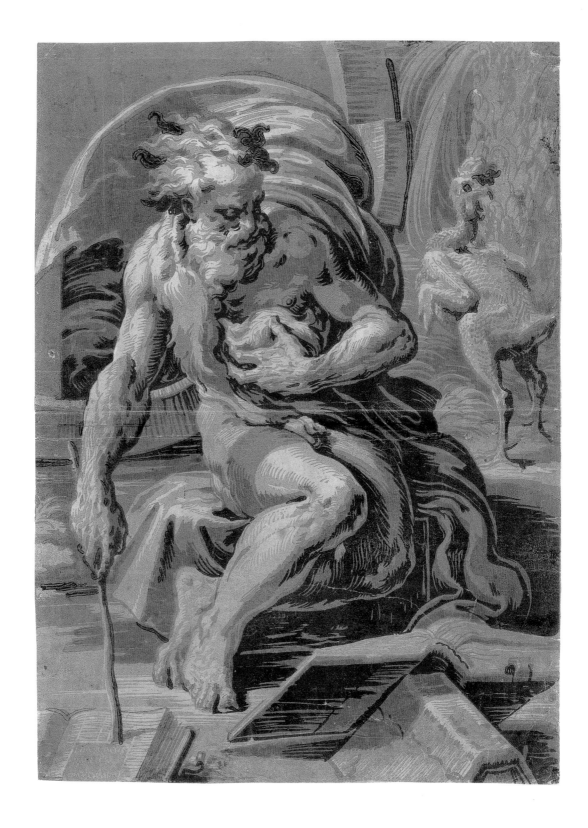

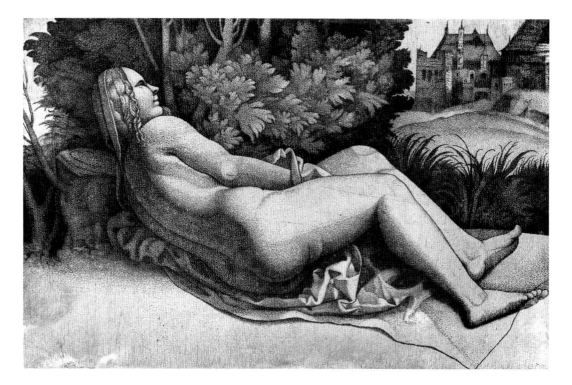

Giulio Campagnola
(Italian, ca. 1482–after 1514)
11 *Venus Reclining in a
Landscape,* ca. 1508–9
Stipple engraving; $4^{11}/_{16} \times 7^{1}/_{8}$
Print Collection, Miriam and
Ira D. Wallach Division of Art,
Prints and Photographs
The New York Public Library,
Astor, Lenox and Tilden
Foundations

Jean Duvet
(French, 1485–after 1561)
12 *Duvet Studying the
Apocalypse,* plate 1 from
The Apocalypse, 1561
Engraving; $11^{7}/_{8} \times 8^{1}/_{2}$
Courtesy, Museum of Fine Arts,
Boston. Reproduced with
permission
1951 Purchase Fund (51.704)
© 2000 Museum of Fine Arts,
Boston. All rights reserved

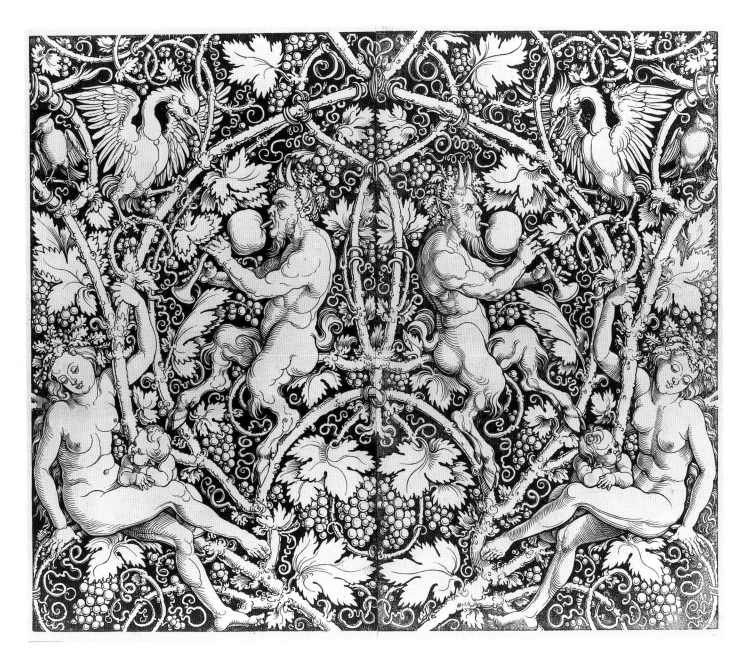

(Hans) Sebald Beham
(German, 1500–1550)
13 *Tapestry of Nymphs and Satyrs,*
n.d.
Woodcut, two panels;
each 21⅜ × 13
The Metropolitan Museum of
Art, New York
Rogers Fund, 1922 (left panel:
22.67.4; right panel: 22.67.5)

Parmigianino (Girolamo
Francesco Maria Mazzola)
(Italian, 1503–1540)
14 *The Two Lovers*, n.d.
Etching; $5^{15}/_{16} \times 4^{3}/_{16}$
The Metropolitan Museum of
Art, New York
Harris Brisbane Dick Fund,
1926 (26.70.3 [102])

After Titian
(Italian, ca. 1485–1576)
15 *The Submersion of the
Pharaoh's Army in the Red Sea*,
ca. 1514–15
Woodcut; $46^{1}/_{2} \times 84^{5}/_{8}$
Courtesy of the Fogg Art
Museum
Harvard University Art
Museums, Cambridge
Gift of W. G. Russell Allen
(M12047)

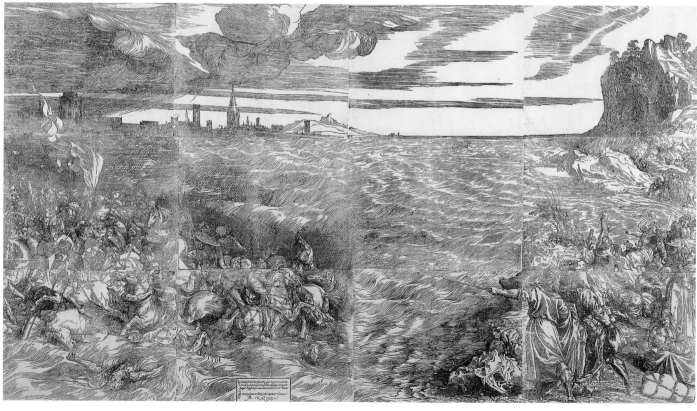

Giorgio Ghisi
(Italian, 1520/24–1582)
16 *Allegory of Life,* 1561
Engraving; 15⅛ × 21½
The Metropolitan Museum of
Art, New York
Harris Brisbane Dick Fund,
1953 (53.600.594)

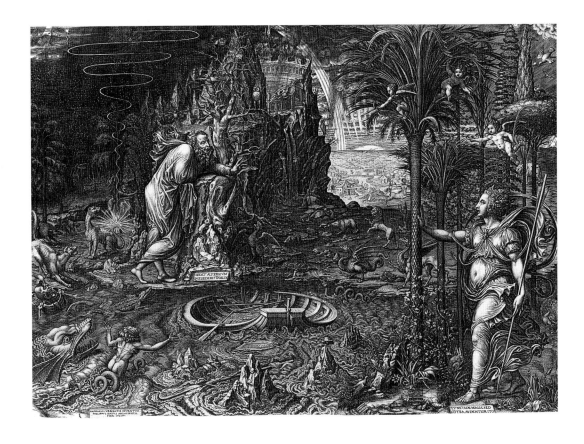

Cornelis Cort
(Dutch, 1522/36–1578)
17 *Martyrdom of Saint Lawrence,*
1571
Engraving; 20 × 14
The Metropolitan Museum of
Art, New York
The Elisha Whittelsey
Collection, The Elisha
Whittelsey Fund, 1949
(49.95.537)

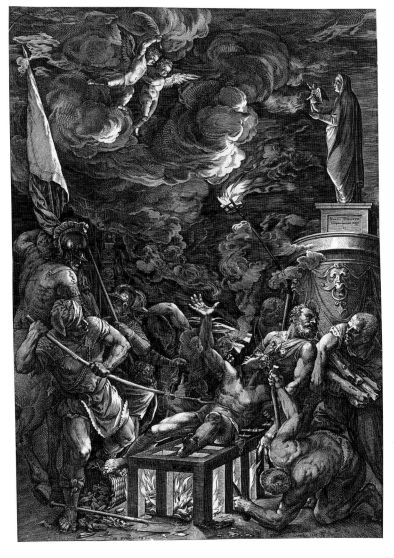

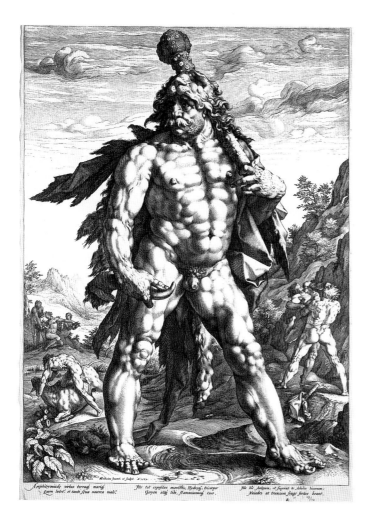

Hendrik Goltzius
(Dutch, 1558–1617)
18 *The Great* (or *Farnese*)
Hercules, 1589
Engraving; 22¼ × 16⅛
National Gallery of Art,
Washington, D.C.
Ailsa Mellon Bruce Fund
(1988.6.1)
Photograph © 2000 Board of
Trustees, National Gallery of
Art, Washington

19 *The Circumcision,*
from the *Meesterstukjes,* 1594
Engraving; 18⅝ × 14
The Metropolitan Museum of
Art, New York
Gift of Henry Walters, 1917
(17.37.36)
All rights reserved, The
Metropolitan Museum of Art

Daniel Kellerthaler
(German, ca. 1574/75–1648)
20 *Venus, Bacchus, and Ceres,*
1607
Punch engraving; 7⅜ × 8⅜
The Metropolitan Museum of
Art, New York
Rogers Fund, 1962 (62.602.655)

Hercules Pietersz Segers
(Dutch, ca. 1589/90–ca. 1638)
21 *Rocky Landscape,* n.d.
Etching and drypoint printed
in dark blue-green on paper
prepared with a gray-green
ground with colored washes;
4⁵/₃₂ × 5⁵/₁₆
The Metropolitan Museum of
Art, New York
Harris Brisbane Dick Fund,
1923 (23.57.3)
© 1986 The Metropolitan
Museum of Art
Photo: Schecter Lee

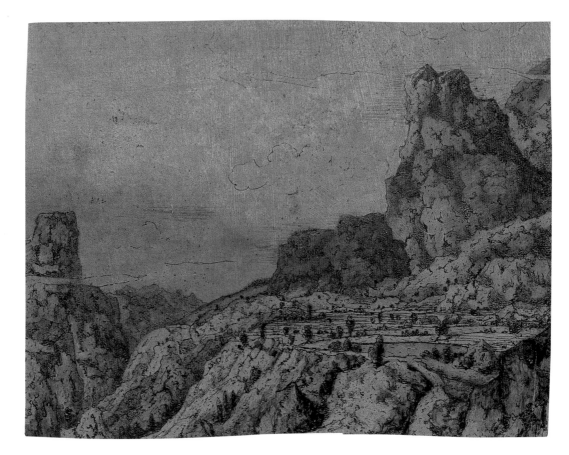

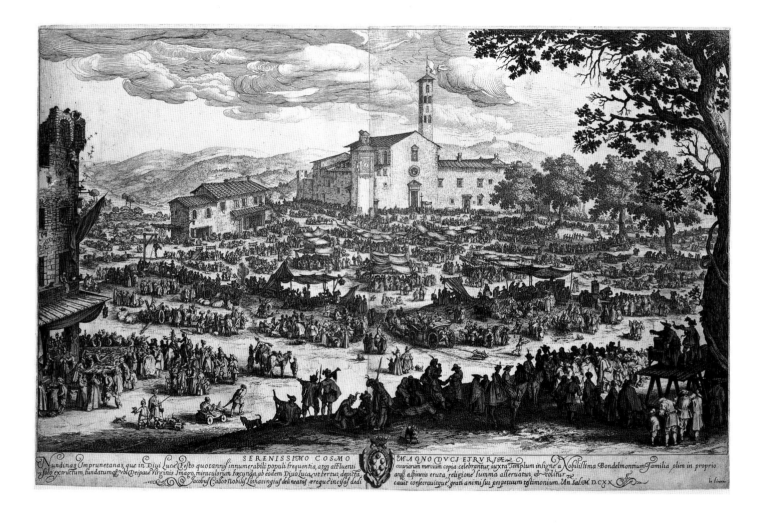

SERENISSIMO COSMO MAGNO DVCI ETRVRIÆ

Nundinas Imprunetanas, quæ in Diui Lucæ Festo quotannis innumerabili populi frequentia, atqg affluenti variarum mercium copia celebrantur, iuxta Templum insigne a Nobilissima Bondelmontium Familia olim in proprio solo extructum, fundatumqg, vbi Deiparæ Virginis Imago, miraculorum fœcunda, ab eodem Diuo Luca, vt fertur, depicta aruf. aspineis eruta, religioné summa asseruatur, & colitur Iacobus Callot Nobilis Lotharingius delineatas æreqg incisas dedi cauit consecrauitqg, grati animi sui perpetuum testimonium. An. Sal. M. DC XX.

Le Sieur

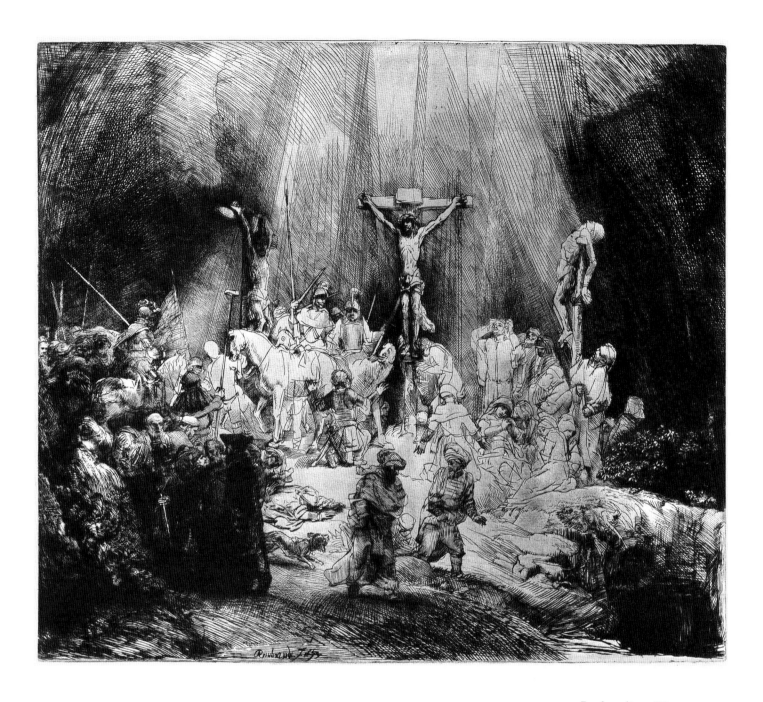

Rembrandt van Rijn
(Dutch, 1606–1669)
28 *Christ Crucified between the Two Thieves (The Three Crosses)*, 1653
Drypoint and burin, state 3/5; $15^{3/16} \times 17^{15/16}$
The Metropolitan Museum of Art, New York
Gift of Felix M. Warburg and his family, 1941 (41.1.32)

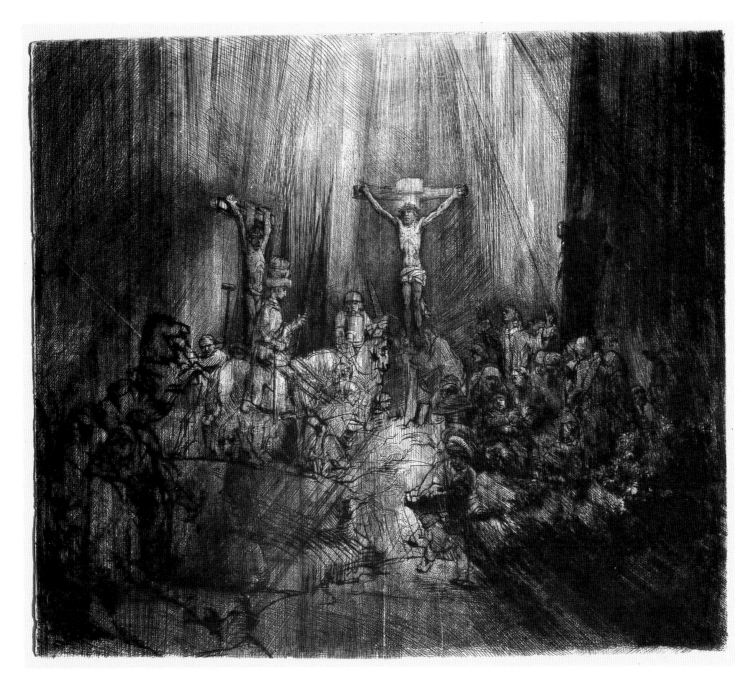

Rembrandt van Rijn
29 *Christ Crucified between the
Two Thieves (The Three Crosses)*,
1653–ca. 1660
Drypoint and burin, state 4/5;
15⅛ × 17¾
Smith College Museum of Art,
Northampton, Massachusetts
Gift of the Studio Club and
Friends, 1911 (1911: 2-1)
Photo: H. Edelstein

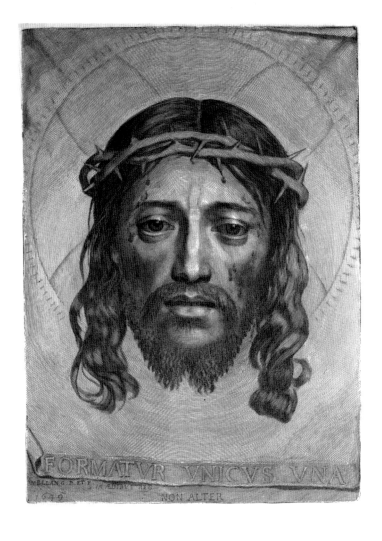

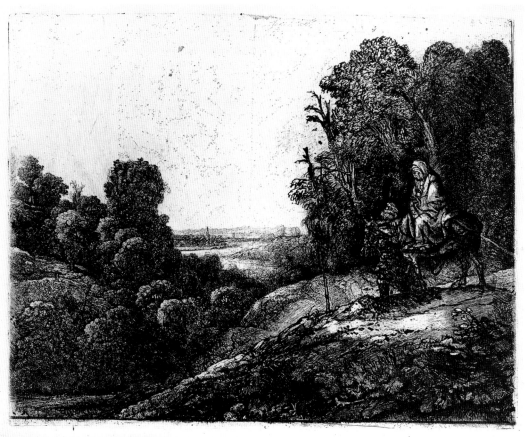

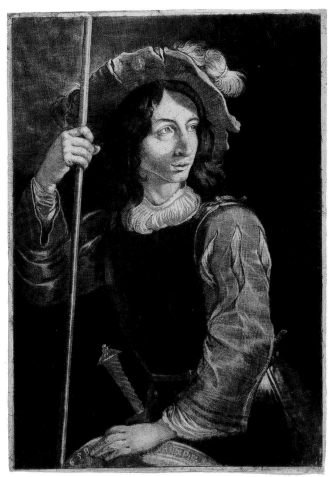

Jan van de Velde IV
(Dutch, before 1610–1686),
after Robert Walker
(British, 1607–1650/60)
31 *Oliver Cromwell*, n.d.
Engraving, aquatint, and
roulette; 16 × 12¹⁄₁₆
The Metropolitan Museum of
Art, New York
Harris Brisbane Dick Fund,
1930 (30.54.72)

Prince Rupert, Count Palatine
(British, 1619–1682)
32 *The Standard Bearer*, 1658
Mezzotint; 11 × 7¾
National Gallery of Art,
Washington, D.C.
Rosenwald Collection
(1948.11.301)
Photo: Lee Ewing

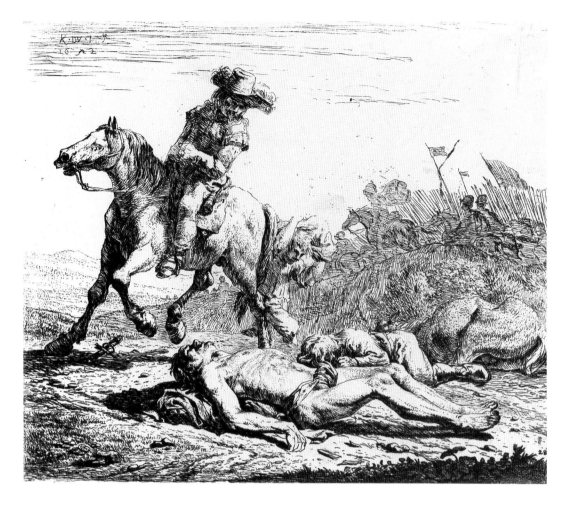

Karel Dujardin
(Dutch, ca. 1622–1678)
33 *The Battlefield*, 1652
Etching; 6⅝ × 7¾
The Baltimore Museum of Art
The Miles White, Jr. Collection
(1976.15.20)

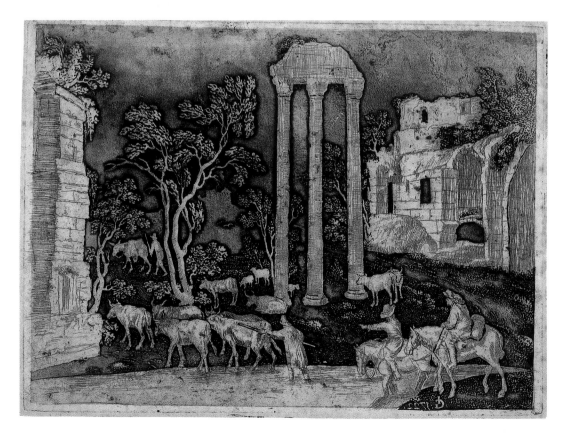

Gerhardt Janssen
(Dutch, 1636–1725)
35 *Pastoral Landscape with
Ruins and a Ford*, 1722
Etching; 6¼ × 8⅝
Print Collection, Miriam and
Ira D. Wallach Division of Art,
Prints and Photographs
The New York Public Library,
Astor, Lenox and Tilden
Foundations

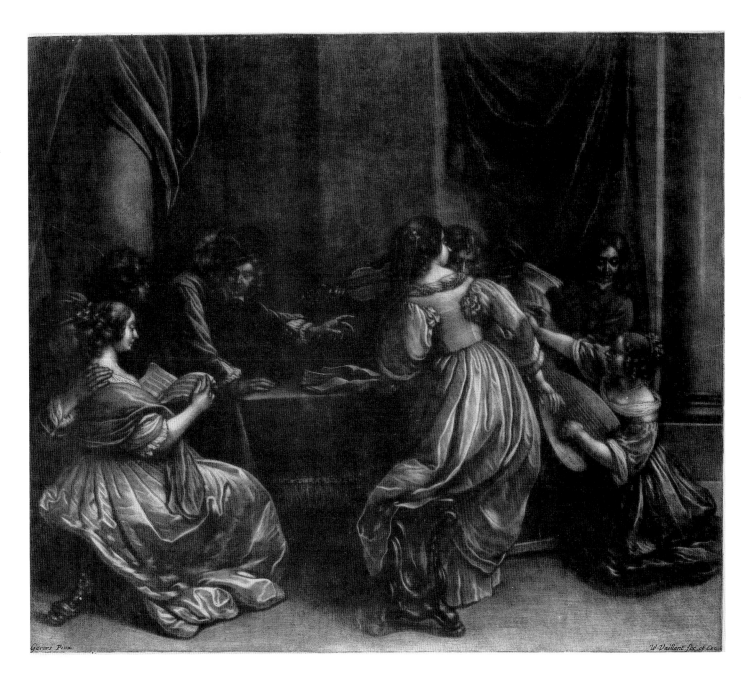

Wallerant Vaillant
(Dutch, 1623–1677)
34 *Musical Party,* n.d.
Mezzotint; 13 × 15½
The Metropolitan Museum of
Art, New York
The Elisha Whittelsey
Collection, The Elisha
Whittelsey Fund, 1951
(51.501.6732)

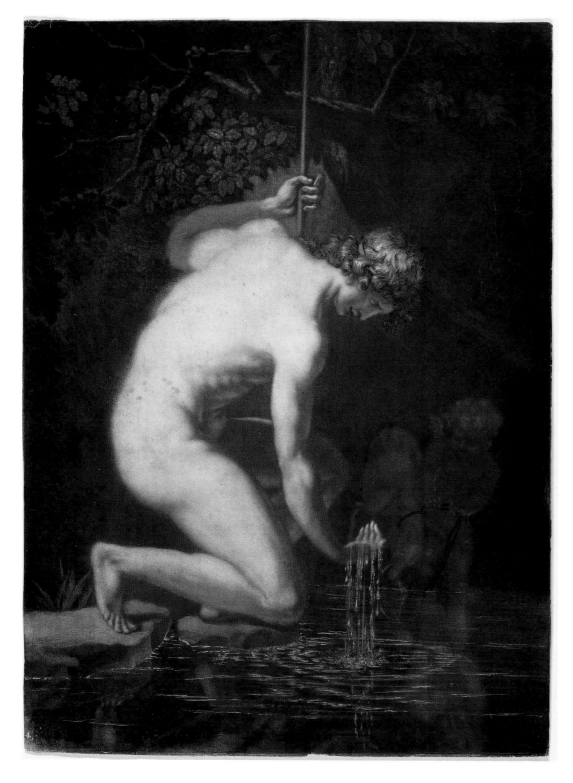

Jakob Christof Le Blon
(German, 1667–1741)
36 *Narcissus*, n.d.
Color mezzotint; 22¼ × 16½
Yale Center for British Art,
New Haven
Paul Mellon Collection
(B1977.14.6323)

Thomas Gainsborough
(British, 1727–1788)
37 *Churchyard with Figure
Contemplating Tombstone,*
1779–80
Soft-ground etching on blue
laid paper; 11⅞ × 15½
Yale Center for British Art,
New Haven
Paul Mellon Collection
(B1977.14.11603)
Photo: Richard Caspole

Cornelis Ploos van Amstel
(Dutch, 1726–1798),
after Hendrick Averkamp
(Dutch, 1585–1634)
38 *The Winter King on the Ice,*
1766
Transfer technique and roulette;
sheet 8½ × 8¾
The Baltimore Museum of Art
The George A. Lucas Collection
(1996.48.13163)

Part of the Town and CASTLE of LUDLOW in Shropshire

Paul Sandby
(British, 1731–1809)
39 *Part of the Town and Castle of Ludlow in Shropshire*, 1779
Etching and aquatint printed in black and brown; 13¾ × 18¼
Yale Center for British Art, New Haven
Paul Mellon Collection (B1977.14.13016)
Photo: Richard Caspole

Richard Earlom
(British, 1743–1822),
after Jan van Huysum
(Dutch, 1682–1749)
40 *Fruit Piece*, 1781, after a 1723 painting by van Huysum
Etching; 22 × 16½
Yale Center for British Art, New Haven
Paul Mellon Fund (B1970.3.547)
Photo: Richard Caspole

41 *A Fruit Piece*, 1781
Mezzotint and etching;
21¹¹⁄₁₆ × 16⅜
Print Collection, Miriam and Ira D. Wallach Division of Art, Prints and Photographs
The New York Public Library, Astor, Lenox and Tilden Foundations

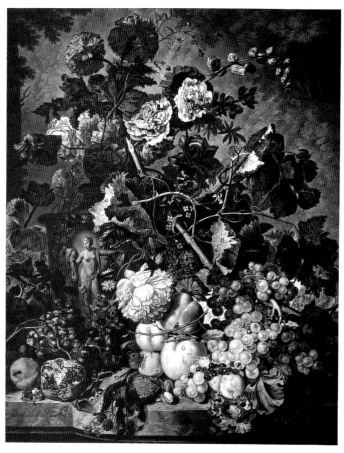

Francisco de Goya y Lucientes
(Spanish, 1746–1828)
42 *Asta su Abuelo (As Far Back as His Grandfather),* plate 39
from *Los Caprichos,* 1799
Etching and aquatint; 8½ × 6
S. P. Avery Collection, Miriam and Ira D. Wallach Division of Art, Prints and Photographs
The New York Public Library, Astor, Lenox and Tilden Foundations

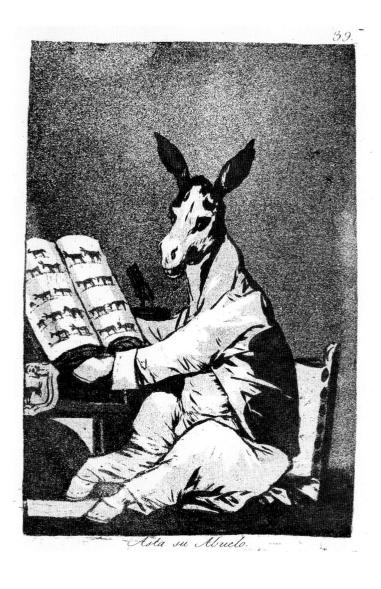

William Blake
(British, 1747–1827)
43 *The Lamb* (recto) and
The Ecchoing Green (verso),
from *Songs of Innocence,* 1789
Hand-colored relief etchings;
sheet 4⅝ × 2¾
Berg Collection of English and American Literature
The New York Public Library, Astor, Lenox and Tilden Foundations

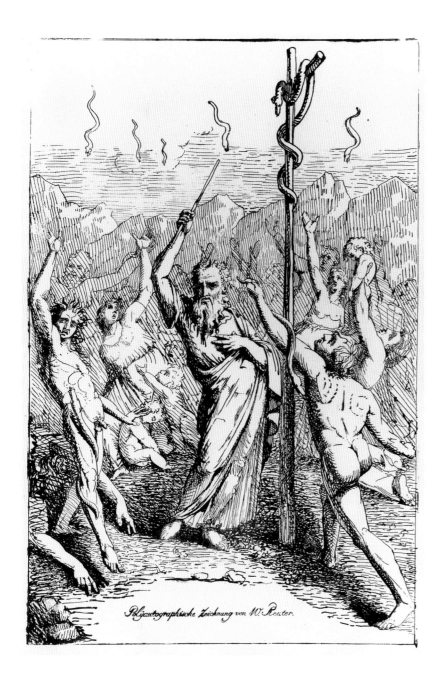

Rodolphe Bresdin
(French, 1822–1885)
47 *Rest on the Flight into Egypt,*
1861/78
Etching and stipple; 11⅜ × 9
The Baltimore Museum of Art
The George A. Lucas Collection
(1996.48.9499)

48 *Rest on the Flight into Egypt,*
1878 (1899 edition)
Transfer lithograph from
etching; 9 × 7¹³⁄₁₆
The Baltimore Museum of Art
Purchase with exchange funds
from the Print Fund (1992.236)

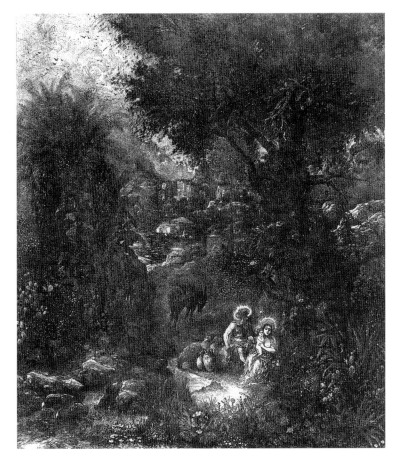

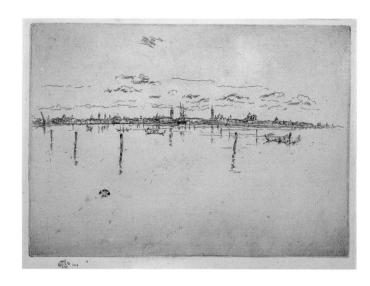

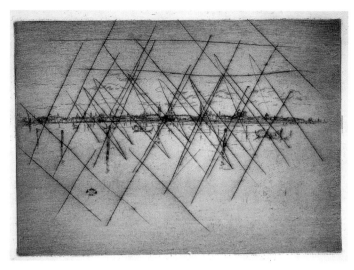

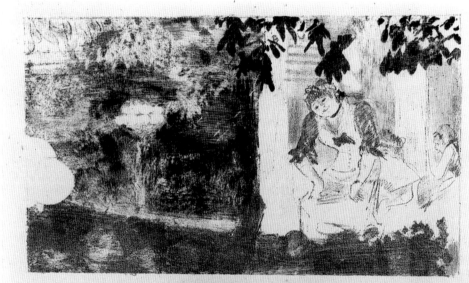

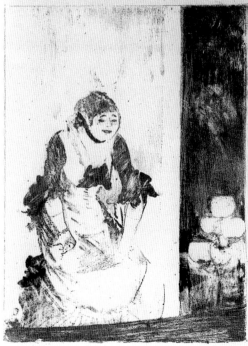

James McNeill Whistler
(American, 1834–1903)
49 *Little Venice*, 1880
Etching on Japan paper;
7½ × 10½
Collection of Dr. Harris Schrank
Photo: Lisa Martin

50 *Little Venice*, 1880
Etching, printed from the
canceled plate; 7½ × 10½
Collection of Dr. Harris Schrank
Photo: Lisa Martin

Edgar Degas
(French, 1834–1917)
51 *Mlle Bécat at the Café des
Ambassadeurs: Three Motifs*,
ca. 1877–78
Lithograph transferred from
three monotypes; 11½ × 9⅝
The Baltimore Museum of Art
Blanche Adler Memorial Fund
(1960.100)

OPPOSITE:
Ludovic Napoléon
(vicomte de) Lepic
(French, 1839–1889)
52 *Vue des bords de l'Escaut:
Effets de neige (View from the
Banks of the Escaut River:
Effect of Snow)*, ca. 1870–76
Etching with monoprint inking;
13⅜ × 28¹⁵⁄₁₆
The Baltimore Museum of Art
The Garrett Collection
(1984.81.22)

53 *Vue des bords de l'Escaut:
La pluie (View from the Banks of the
Escaut River: Rain)*, ca. 1870–76
Etching with monoprint inking;
13⁷⁄₁₆ × 29
The Baltimore Museum of Art
The Garrett Collection
(1984.81.10)

60

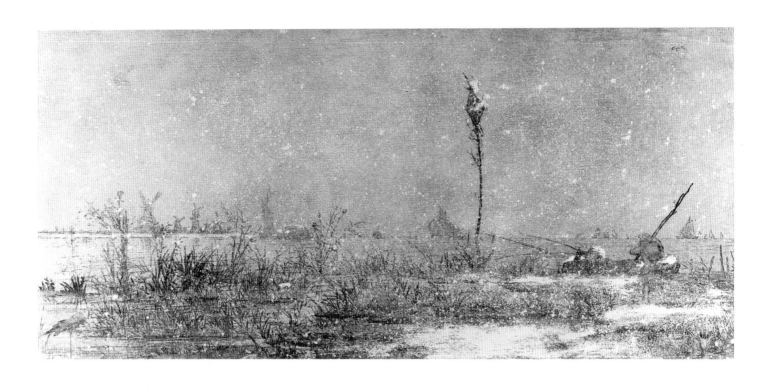

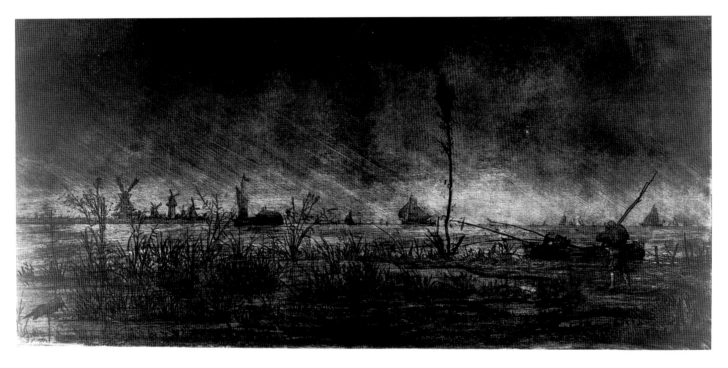

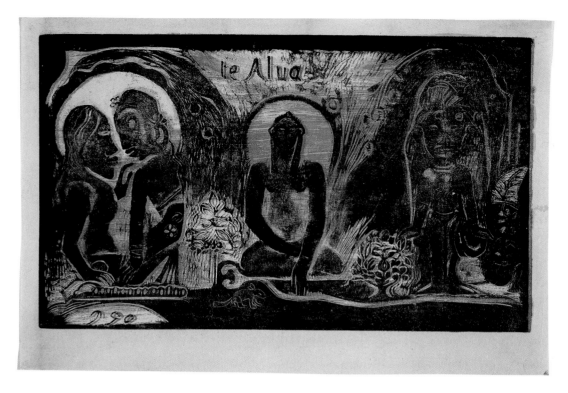

Paul Gauguin
(French, 1848–1903)
54 *Te Atua (The Gods),* from
the *Noa Noa* series, 1893–94
Woodcut on endgrain
boxwood, printed in color;
8 × 13⅞
The Museum of Modern Art,
New York
Gift of Abby Aldrich Rockefeller
Photo: © 2000 The Museum of
Modern Art, New York

Timothy Cole
(American, 1852–1931),
after Eugène Carrière
(French, 1849–1906)
55 *La Maternité (Motherhood),*
1909
Wood engraving; 6¹¹/₁₆ × 8¼
Print Collection, Miriam and
Ira D. Wallach Division of Art,
Prints and Photographs
The New York Public Library,
Astor, Lenox and Tilden
Foundations

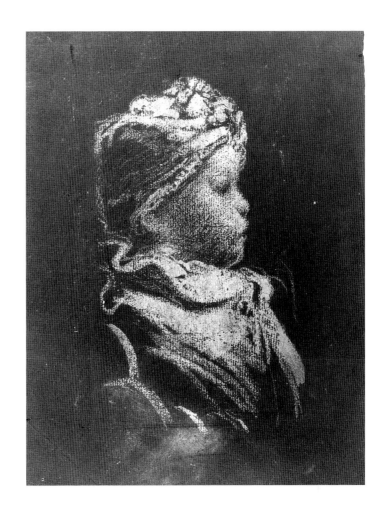

Arthur B. Davies
(American, 1862–1928)
56 *The Baby,* ca. 1893
Original transfer drawing in
white litho crayon on black
prepared paper; 11 × 7¼
Print Collection, Miriam and
Ira D. Wallach Division of Art,
Prints and Photographs
The New York Public Library,
Astor, Lenox and Tilden
Foundations

57 *The Baby,* ca. 1893
Lithograph printed in white on
black paper; 10¼ × 7½
Print Collection, Miriam and
Ira D. Wallach Division of Art,
Prints and Photographs
The New York Public Library,
Astor, Lenox and Tilden
Foundations

58 *The Baby,* ca. 1893
Lithograph printed in black on
white paper; 11 × 7¼
Print Collection, Miriam and
Ira D. Wallach Division of Art,
Prints and Photographs
The New York Public Library,
Astor, Lenox and Tilden
Foundations

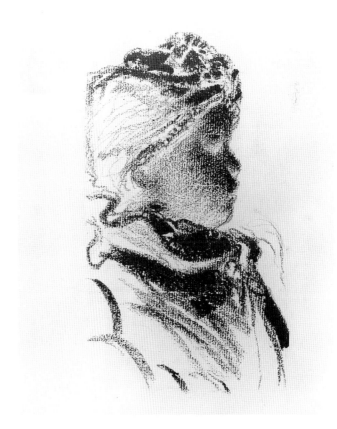

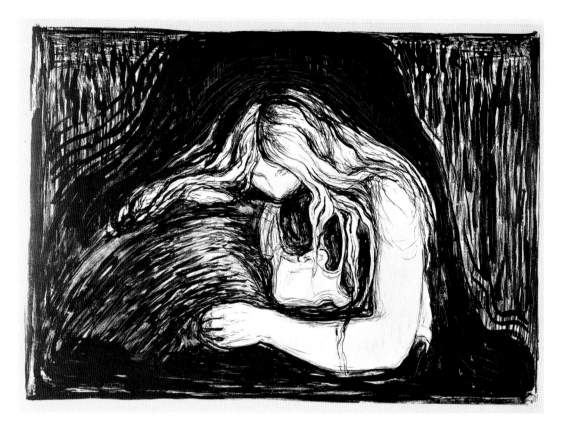

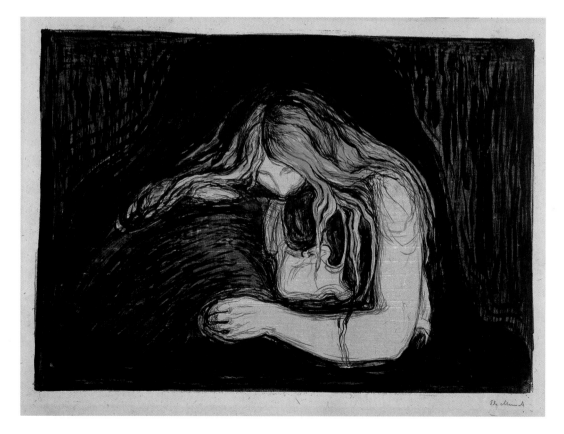

Edvard Munch
(Norwegian, 1863–1944)
59 *Vampire,* 1895 (signed 1897)
Lithograph printed in black;
15¼ × 21⅜
The Museum of Modern Art,
New York
The William B. Jaffe and Evelyn
A. J. Hall Collection (308.50)
© 2000 The Munch
Museum/The Munch-Ellingsen
Group/Artists Rights Society
(ARS), New York
Photo: © 2000 The Museum of
Modern Art, New York

60 *Vampire,* 1895–1902
Lithograph printed in color and
woodcut; 15 × 21¾
The Museum of Modern Art,
New York
The William B. Jaffe and Evelyn
A. J. Hall Collection (1167.68)
© 2000 The Munch Museum/
The Munch-Ellingsen Group/
Artists Rights Society (ARS),
New York
Photo: © 2000 The Museum of
Modern Art, New York

OPPOSITE, TOP LEFT:
61 *Model in Collar and Hood,*
1897
Aquatint; 15⅝ × 11¾
The Museum of Modern Art,
New York
Purchase (1183.68)
© 2000 The Munch Museum/
The Munch-Ellingsen Group/
Artists Rights Society (ARS),
New York
Photo: © 2000 The Museum of
Modern Art, New York

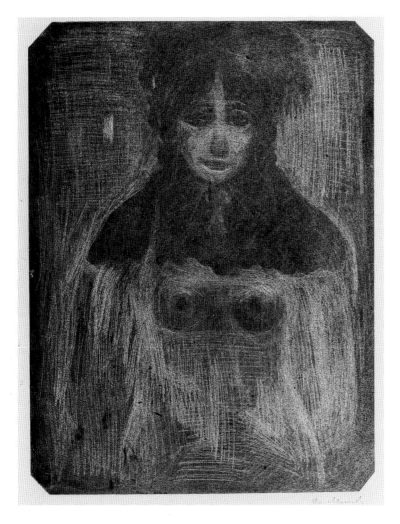

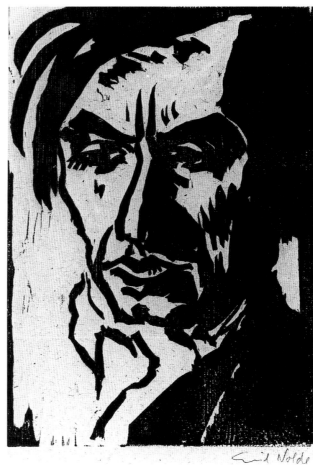

TOP RIGHT:
Emil Nolde
(German, 1867–1956)
63 *Der Sänger (The Singer)*, 1911
Woodcut; sheet 12 × 9
The Baltimore Museum of Art
Gift of Ben Wunsch, New York,
by exchange (1988.113)

RIGHT:
62 *Liegendes Weib (Reclining Woman)*, 1908
Etching and aquatint printed in color; 12⅛ × 18⅝
The Museum of Modern Art, New York
Purchase (562.51)
Photo: © 2000 The Museum of Modern Art, New York

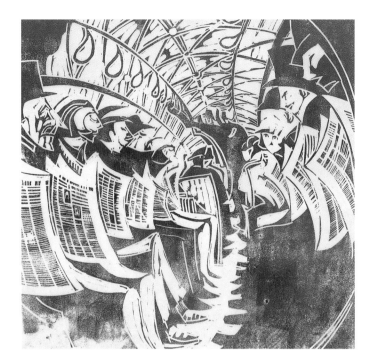

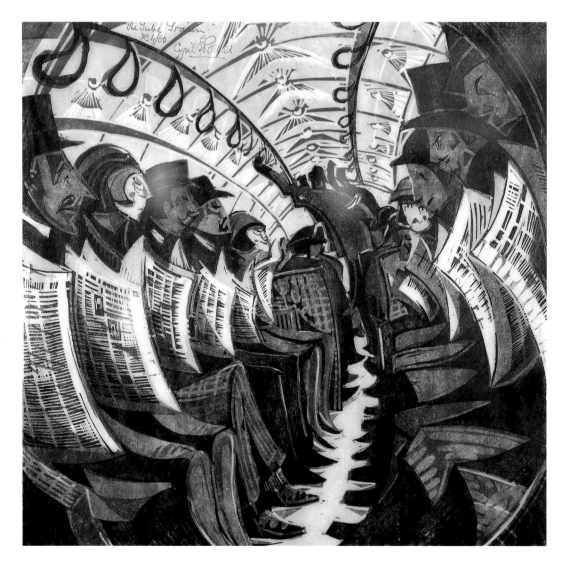

Cyril Power
(British, 1872–1951)
64 *The Tube Train,* ca. 1930/32
Trial proof in blue for color
woodcut; 11⅞ × 12⁷⁄₁₆
Collection of Johanna and
Leslie Garfield
Photo: Lisa Martin

65 *The Tube Train,* ca. 1930/32
Trial proof in green for color
woodcut; 11⅞ × 12⁷⁄₁₆
Collection of Johanna and
Leslie Garfield
Photo: Lisa Martin

66 *The Tube Train,* ca. 1930/32
Color woodcut, final state;
11⅞ × 12⅜
Edition of 60
Collection of Johanna and
Leslie Garfield
Photo: Lisa Martin

Jean-Emile Laboureur
(French, 1877–1943)
67 *Asperges et radis*
(Asparagus and Radishes), 1928
Pencil on paper; 6¼ × 9⅛
Collection of Dr. Harris Schrank
Photo: Lisa Martin

68 *Asperges et radis*
(Asparagus and Radishes), 1928
Engraving, state 1; 7 × 9½
Edition of 7
Collection of Dr. Harris Schrank
Photo: Lisa Martin

69 *Asperges et radis*
(Asparagus and Radishes), 1928
Engraving, state 2; 7 × 9½

Edition of 8
Collection of Dr. Harris Schrank
Photo: Lisa Martin

70 *Asperges et radis*
(Asparagus and Radishes), 1928
Engraving, state 3; 7 × 9½
Edition of 9
Collection of Dr. Harris Schrank
Photo: Lisa Martin

71 *Asperges et radis*
(Asparagus and Radishes), 1928
Engraving, state 4; 7 × 9½
Edition of 35
Collection of Dr. Harris Schrank
Photo: Lisa Martin

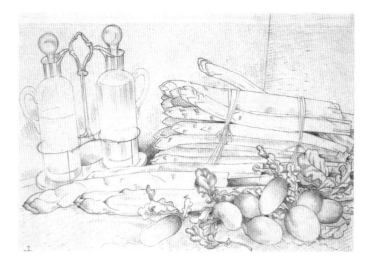

67

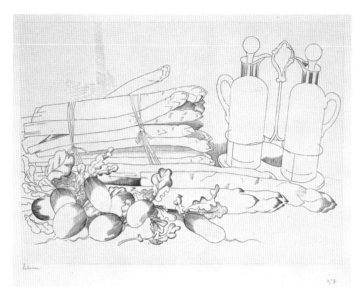

68

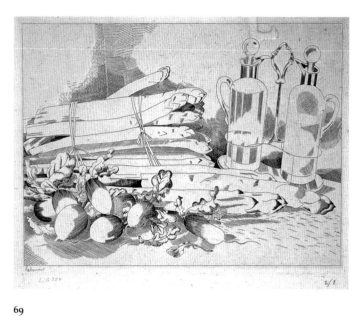

69

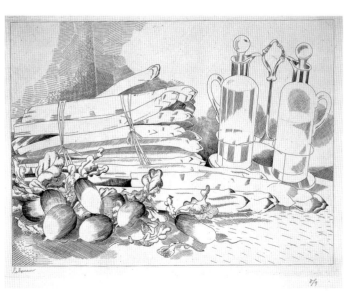

70

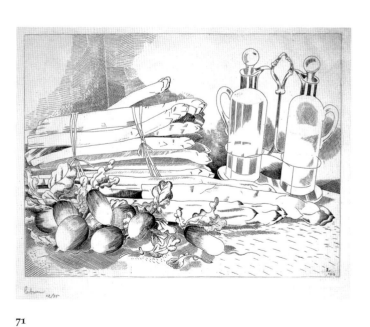

71

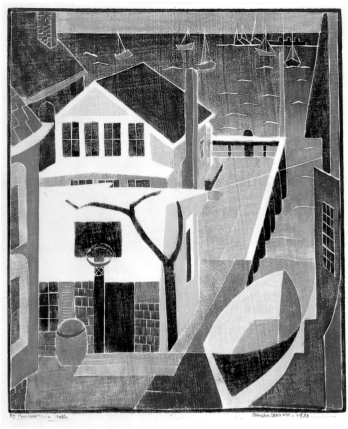

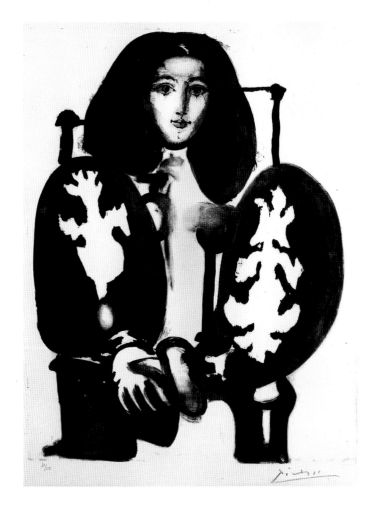

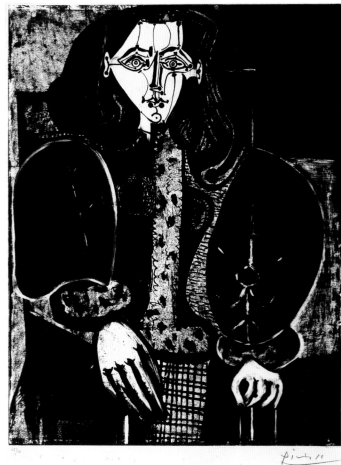

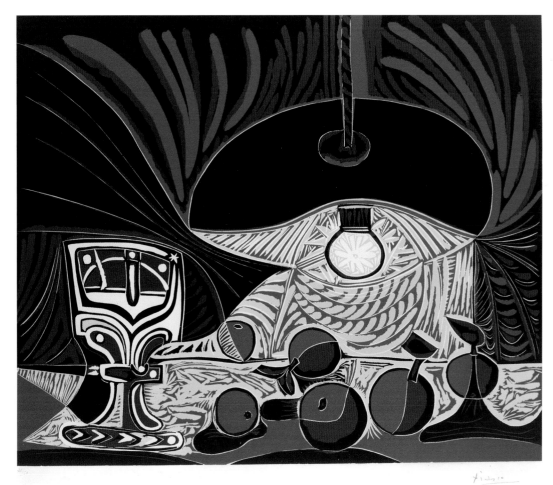

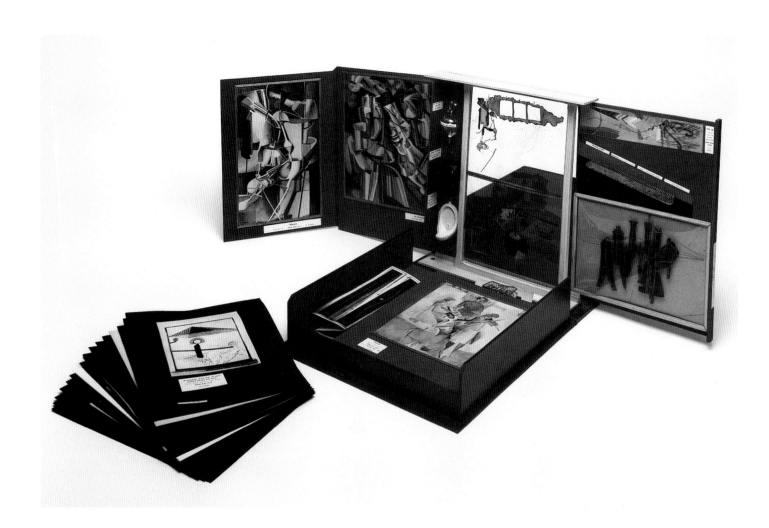

Marcel Duchamp
(French, 1887–1968)
77 *Boite-en-valise
(Box in a Valise)*, 1941
Leather- and cloth-covered box
containing various media on
various supports; box 15 × 16
Davison Art Center, Wesleyan
University
Photograph courtesy of the
Philadelphia Museum of Art:
Gift of Mme Marcel Duchamp
(1994-43-1)
© 2000 Artists Rights Society
(ARS), New York/ADAGP,
Paris/Estate of Marcel Duchamp
Photo: Graydon Wood

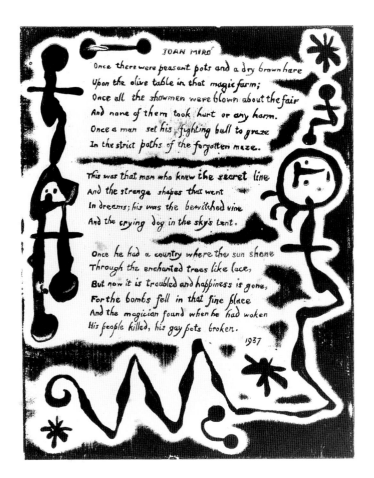

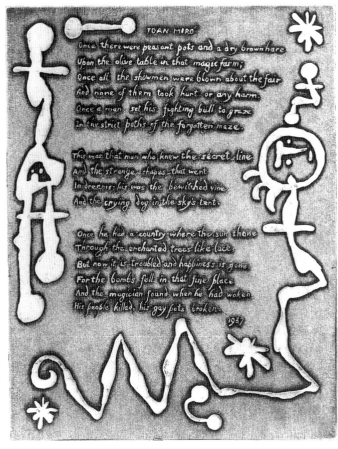

Joan Miró
(Spanish, 1893–1983),
in collaboration with Ruthven
Todd (British, 1914–1978)
78 *Joan Miró,* 1947
Intaglio plate printed as relief;
6¾ × 5½
Print Collection, Miriam and
Ira D. Wallach Division of Art,
Prints and Photographs
The New York Public Library,
Astor, Lenox and Tilden
Foundations
© 2000 Artists Rights Society
(ARS), New York/ADAGP,
Paris

79 *Joan Miró,* 1947
Intaglio plate printed as
intaglio; 6¾ × 5½
Print Collection, Miriam and
Ira D. Wallach Division of Art,
Prints and Photographs
The New York Public Library,
Astor, Lenox and Tilden
Foundations
© 2000 Artists Rights Society
(ARS), New York/ADAGP,
Paris

RIGHT:
80 *Joan Miró,* 1947
Intaglio plate printed as intaglio
in color; 6¾ × 5½
Print Collection, Miriam and
Ira D. Wallach Division of Art,
Prints and Photographs
The New York Public Library,
Astor, Lenox and Tilden
Foundations
© 2000 Artists Rights Society
(ARS), New York/ADAGP,
Paris

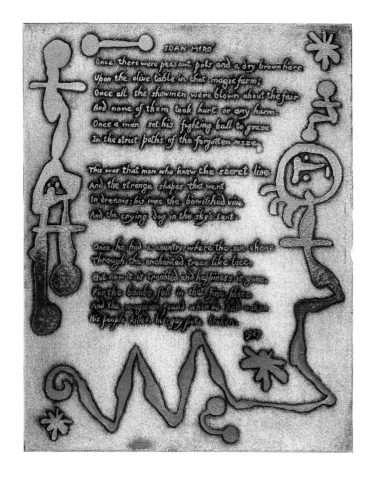

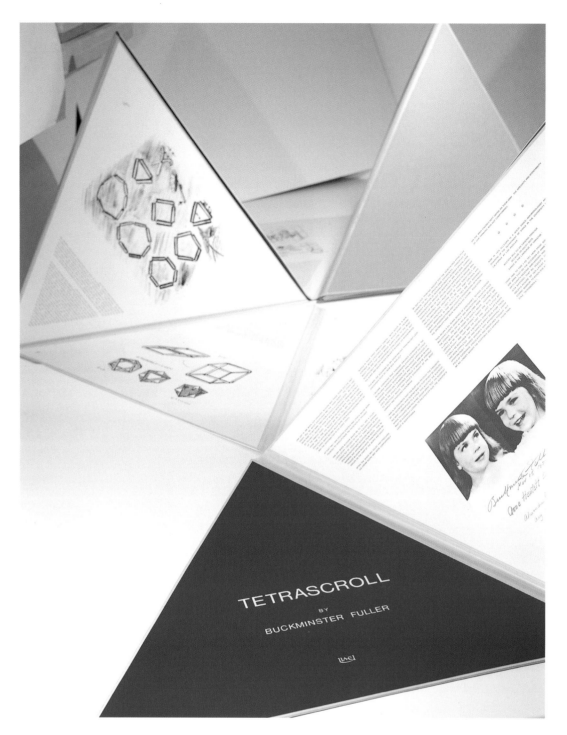

Buckminster Fuller
(American, 1895–1983)
81 *Tetrascroll*, 1975–77
Book of twenty-one lithographs with text, a title page, a preface page, an epilever, and a colophon page made from twenty-five stones and twenty-seven plates; twenty-six sections, each an equilateral triangle; bound in Dacron polyester sailcloth, hinged to form a continuous single object; sheet 35½ × 35½ × 35½ (each)
Edition of 34
Published by Universal Limited Art Editions, West Islip, New York
Philadelphia Museum of Art Purchase, Alice Newton Osborn Fund
© Universal Limited Art Editions

Louise Bourgeois
(American, b. 1911)
83 *Henriette*, 1998
Color lithograph with Iris-print
multiple; 46 × 31½
Edition of 50
Published by Solo Impression,
Inc., New York
© Louise Bourgeois/Licensed
by VAGA, New York, NY
Photo: John Back

84 *Crochet I*, 1998
Mixografia print on handmade
paper; 37 × 31
Edition of 64
Published by Remba Gallery/
Mixografia Workshop, West
Hollywood, California, and
Solo Impression, Inc., New York
© Louise Bourgeois/Licensed
by VAGA, New York, NY

John Cage
(American, 1912–1992)
85 *Empty Fire* (trial proof for
Dramatic Fire), 1989
Aquatint on smoked paper;
18¼ × 23
Edition of 25
Published by Crown Point
Press, San Francisco
Courtesy Crown Point Press

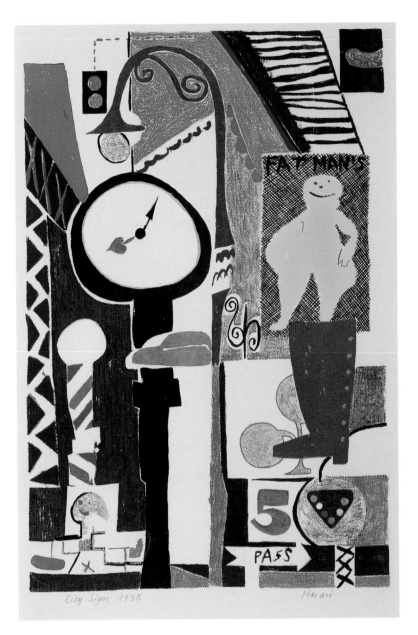

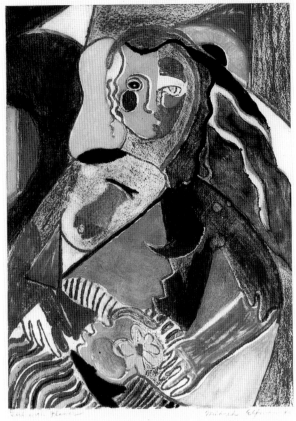

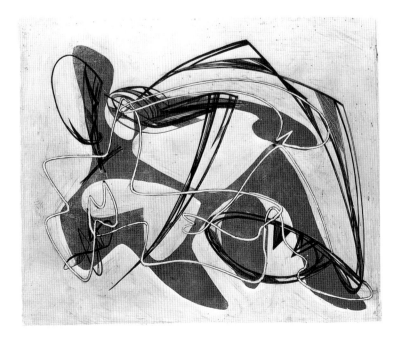

Hananiah Harari
(American, b. 1912)
86 *City Signs,* 1938
Color screenprint; 18 × 12
Print Collection, Miriam and
Ira D. Wallach Division of Art,
Prints and Photographs
The New York Public Library,
Astor, Lenox and Tilden
Foundations

Mildred Elfman
(American, b. 1912?)
87 *Girl with Flower,* 1938–40
Colored carborundum etching;
sheet 12⅜ × 10⅝
United States General Services
Administration, formerly
Federal Works Programs
Administration, on extended
loan to the The Baltimore
Museum of Art (1943.9.477)

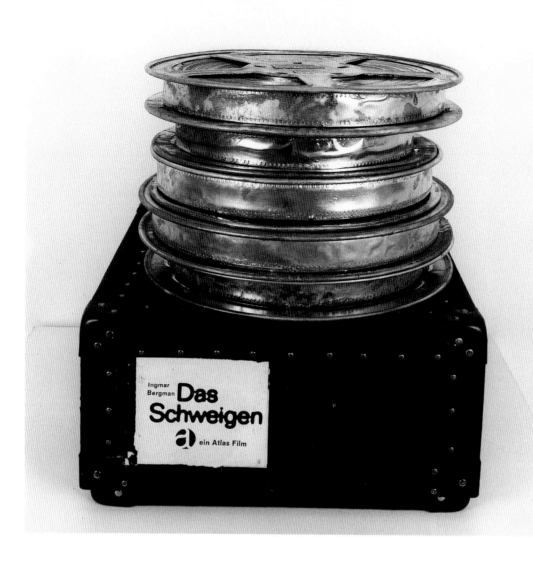

Joseph Beuys
(German, 1921–1986)
88 *Das Schweigen (The Silence),*
1973
Five reels of 35-mm film of
Ingmar Bergman's *The Silence*
(1962), covered in zinc, each
reel titled by Beuys according
to its context, in film carton
(metal reels with original
copies [German version] were
covered with varnish, then
dipped in copper and zinc
baths); 10 × 16½ × 16½
Titles (impressed on metal tags):
Reel 1:
HUSTENANFALL —
GLETSCHER +
(Coughing Fit — Glacier +)
Reel 2:
ZWERGE — ANIMAL-
ISIERUNG (Dwarves —
Animalization)
Reel 3:
VERGANGENHEIT —
VEGETABILISIERUNG
(Past — Vegetabilization)
Reel 4:
PANZER —
MECHANISIERUNG
(Tank — Mechanization)
Reel 5:
Wir sind frei GEYSIR +
(We are free Geyser +)
Edition of 50
Published by Edition René
Block, Berlin, and Multiples,
Inc., New York
© 2000 Artists Rights Society
(ARS), New York/
VG Bild-Kunst, Bonn
Photo: Zindman/Fremont

89 *American Hare Sugar,* 1974
Color offset lithograph;
24¾ × 35½
Edition of 40
Published by Edition Staeck,
Heidelberg
Collection of The Chase
Manhattan Bank
Courtesy Ronald Feldman
Fine Arts
© 2000 Artists Rights Society
(ARS), New York/
VG Bild-Kunst, Bonn

Roy Lichtenstein
(American, 1923–1997)
90 *Moonscape*, 1965
Screenprint; 19¹⁵⁄₁₆ × 23¹⁵⁄₁₆
Edition of 200
Published by Original Editions,
New York
© Estate of Roy Lichtenstein

91 *Folded Hat*, from the port-
folio *SMS* 4, 1968
Silkscreened in red, yellow,
blue, and white on vinyl;
handfolded; 16¾ × 14¹⁵⁄₁₆ sheet
folded to make 14¾ × 8¼ × ½
three-dimensional hat
Edition of approximately 2,000
Published by The Letter Edged
in Black Press, New York
Reinhold-Brown Gallery,
New York

Richard Artschwager
(American, b. 1924)
92 *Locations,* 1969
Formica on wood and five blps
made of wood, glass, plexiglass,
and rubberized horsehair with
formica; 15 × 10¾ × 5
Edition of 90
Published by Brooke Alexander
Editions, New York
© 2000 Richard Artschwager/
Artists Rights Society (ARS),
New York

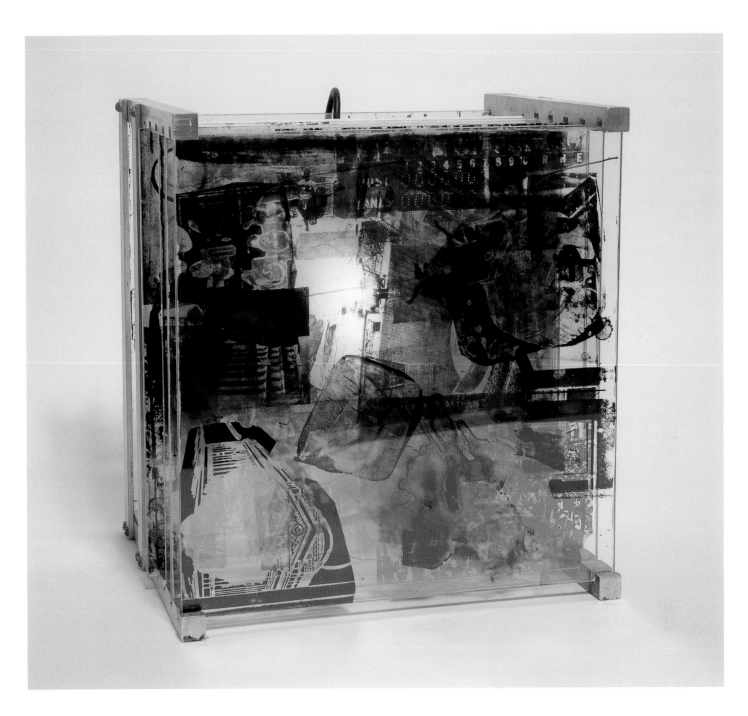

Robert Rauschenberg
(American, b. 1925)
93 *Shades*, 1964
Six lithographs printed on
plexiglass panels, mounted
(five interchangeably) in slotted
aluminum box on optional iron
stand designed by artist, illumi-
nated by movable light bulb
that blinks or burns steadily;
box 15 × 14⅜ × 11⅝
Edition of 24
Published by Universal Limited
Art Editions, West Islip, New
York
© Untitled Press, Inc. and
U.L.A.E./Licensed by VAGA,
New York, NY
Photo: Sally Ritts

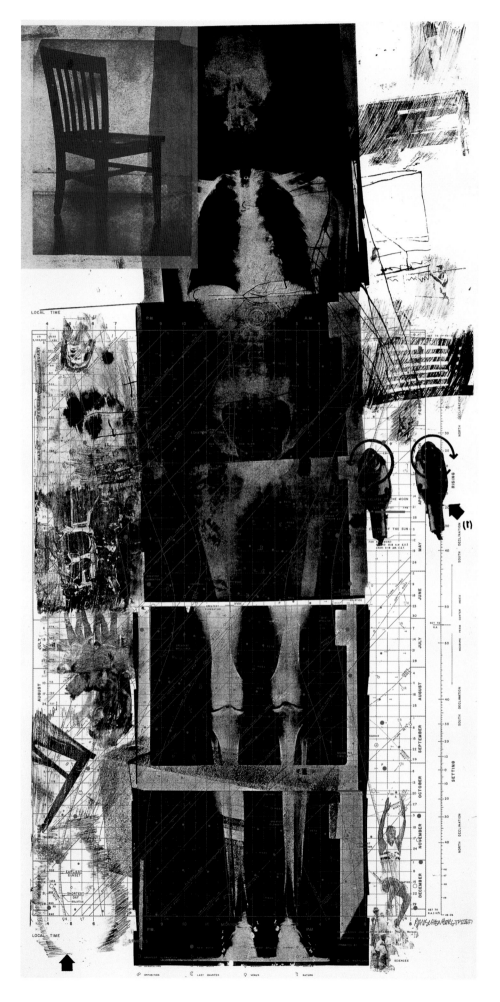

Robert Rauschenberg
94 *Booster,* 1967
Lithograph and screenprint in
four colors; 72 × 35½
Edition of 38
Published by Gemini G.E.L.,
Los Angeles
© Untitled Press, Inc. and
Gemini G.E.L., Los Angeles/
Licensed by VAGA, New York,
NY

Robert Rauschenberg
95 *Cardbird Box I*, 1971
Five-color photo-offset printing
on paper, laminated to corru-
gated cardboard, die cut and
folded over wood form, with
paper tape, reinforced tape,
a staple, and clear matte acrylic;
9 × 12⅛ × 10½ (variable)
Edition of 20
Published by Gemini G.E.L.,
Los Angeles
© Untitled Press, Inc. and
Gemini G.E.L., Los Angeles/
Licensed by VAGA, New York,
NY

96 *Sling Shots Lit #5*, 1985
Light box assemblage with
lithography and screenprint;
84½ × 54 × 12
Edition of 25
Published by Gemini G.E.L.,
Los Angeles
© Untitled Press, Inc. and
Gemini G.E.L., Los Angeles/
Licensed by VAGA, New York,
NY

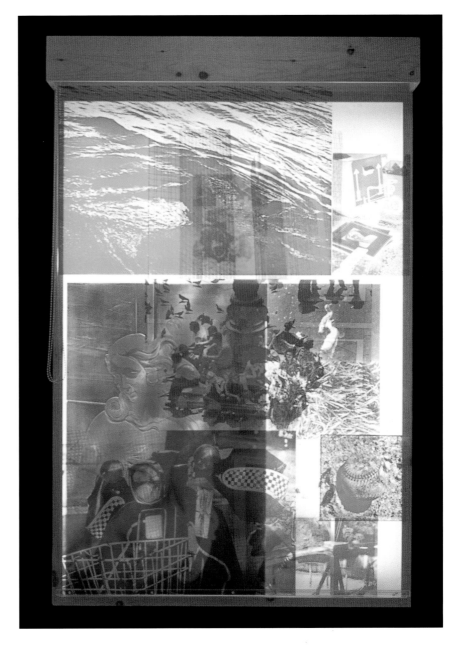

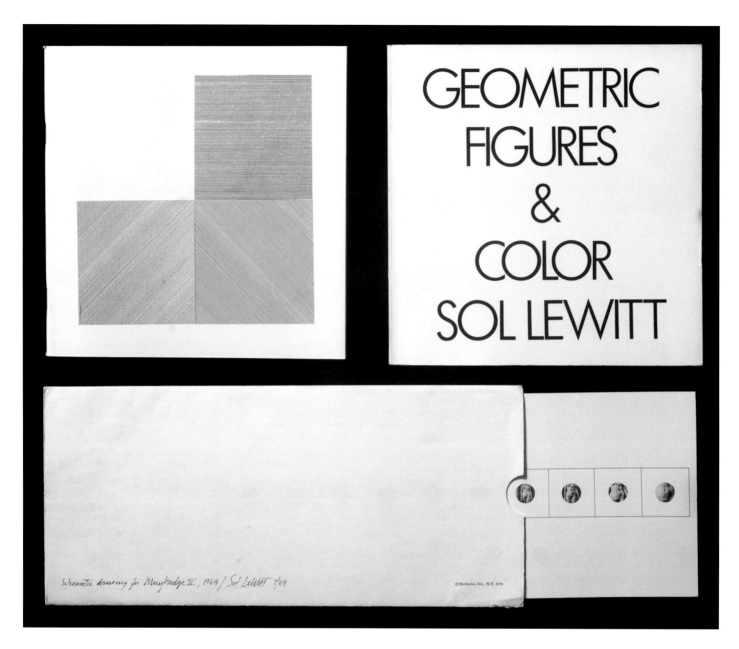

Sol LeWitt
(American, b. 1928)
97 *Four Basic Kinds of Lines & Color*, 1969
Book, 36 pages; offset lithography; 7⅞ × 7⅞
Edition size unknown
Published by Lisson Gallery and Studio International, London
LeWitt Collection, Chester, Connecticut
© 2000 Sol Lewitt/Artists Rights Society (ARS), New York
Photograph courtesy of Printed Matter, Inc., New York
Photo: © 1999 D. James Dee

98 *Schematic Drawing for Muybridge II*, 1970
Offset lithograph printed in one color on sheet of paper inserted in paper sleeve; 5⅛ × 12⁹⁄₁₆ (overall size varies)
Edition size unknown

Published by Multiples, Inc., New York
LeWitt Collection, Chester, Connecticut
© 2000 Sol Lewitt/Artists Rights Society (ARS), New York
Photograph courtesy of Printed Matter, Inc., New York
Photo: © 1999 D. James Dee

99 *Geometric Figures & Color*, 1979
Book, 48 pages; offset lithography; 8 × 8
Edition size unknown
Published by Harry N. Abrams, Inc., New York
LeWitt Collection, Chester, Connecticut
© 2000 Sol Lewitt/Artists Rights Society (ARS), New York
Photograph courtesy of Printed Matter, Inc., New York
Photo: © 2000 D. James Dee

Andy Warhol
(American, 1928–1987)
100 *Brillo Boxes*, 1964
Synthetic polymer paint and
silkscreen on wood; white
boxes 17 × 17 × 14; yellow box
13 × 16 × 11½
The Andy Warhol Museum,
Pittsburgh
Founding Collection,
Contribution The Andy Warhol
Foundation for the Visual Arts,
Inc. (SC 10.019, SC 10.006,
SC 10.007, SC 10.004)
© 2000 Andy Warhol
Foundation for the Visual Arts/
Artists Rights Society (ARS),
New York
Photo: Richard Stoner

101 *Cow Wallpaper,* 1966
Cow screenprints on cow wall-
paper; roll 108 × 28
The Andy Warhol Museum,
Pittsburgh
© 2000 Andy Warhol
Foundation for the Visual Arts/
Artists Rights Society (ARS),
New York
Photo: Paul Rocheleau

Installation view of Andy
Warhol's *Cow Wallpaper*

Claes Oldenburg
(American, b. 1929)
102 *Profile Airflow*, 1969
Cast-polyurethane relief over
lithograph in two colors on
white, thick, slightly textured
(2) Special Arjomari paper, in
welded aluminum frame;
33½ × 65½ × 4
Edition of 75
Published by Gemini G.E.L.,
Los Angeles
Collection of Oldenburg
van Bruggen Foundation

Jasper Johns
(American, b. 1930)
103 *Bread*, 1969
Lead relief; 23 × 17
Edition of 60
Published by Gemini G.E.L.,
Los Angeles
© 1969 Jasper Johns and Gemini
G.E.L., Los Angeles/Licensed
by VAGA, New York, NY

104 *The Critic Smiles*, 1969
Lead relief; 23 × 17
Edition of 60
Published by Gemini G.E.L.,
Los Angeles
© 1969 Jasper Johns and Gemini
G.E.L., Los Angeles/Licensed
by VAGA, New York, NY

105 *Target*, 1971
For the exhibition catalogue
*Techniques and Creativity: Gemini
G.E.L;* offset lithograph with
collage of watercolor pads and
brush in plastic clamshell box
with exhibition catalogue;
box (closed) 10½ × 8½ × 1¼;
print 12¼ × 10
Edition of 22,500
Published by Gemini G.E.L.,
Los Angeles, and The Museum
of Modern Art, New York
© 1971 Jasper Johns and Gemini
G.E.L., Los Angeles/Licensed
by VAGA, New York, NY
Photo: © 2000 D. James Dee

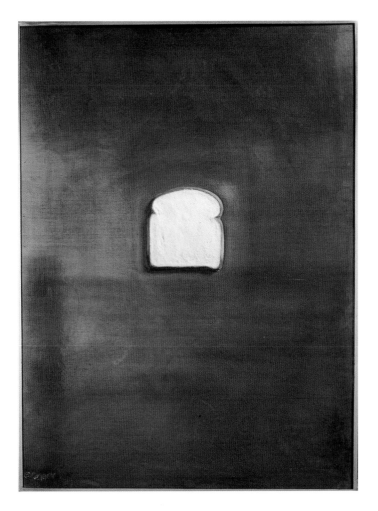

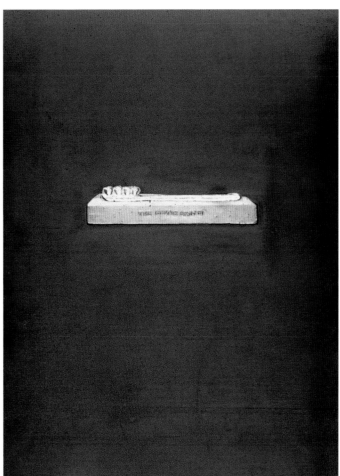

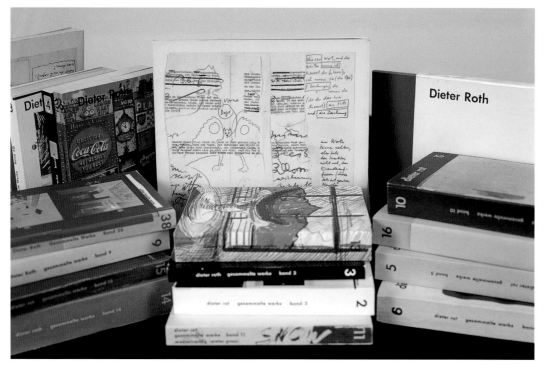

Dieter Roth
(Swiss, 1930–1998)
106 Collected works,
volumes 1–40, 1957–77
Forty books printed by offset
lithography; various publishers
Courtesy Nolan/Eckman
Gallery, New York
Photos: Lisa Martin

Installation views of Dieter
Roth's collected works

Dieter Roth
107 *Literaturwürst*
(Literature Sausage), 1961–70
Cut up books with water and
gelatine, or lard, and spices in
sausage skin; 15⅝ × 4¹¹⁄₁₆
Edition of 50
Published by René Block, Berlin
Collection Hansjorg Mayer,
London
Photo: Heini Schneebeli

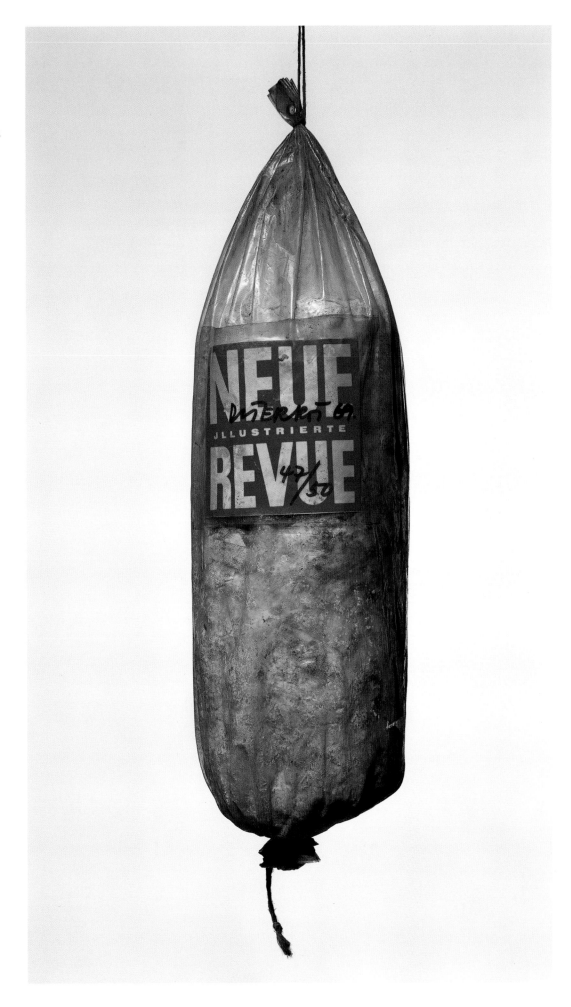

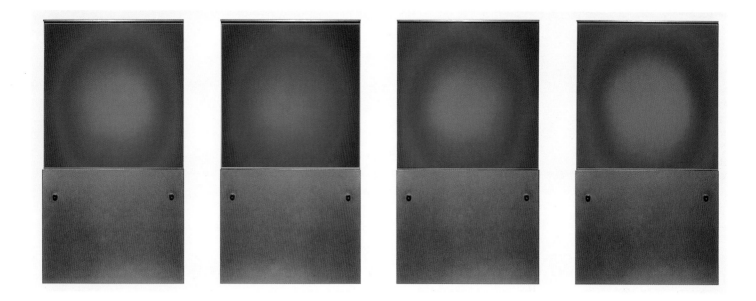

Robert Ryman
(American, b. 1930)
108 *Spectrogram I (Blue)*, 1998
Working proof; four-part holo-
gram mounted on anodized
aluminum panels, each with
five ¼″ screws, 2 machine
screws; each panel 11 × 11,
overall 19½ × 11
Not editioned
Constructed by C Project,
Miami Beach, Florida
Private collection

John Baldessari
(American, b. 1931)
109 *The Fallen Easel,* 1988
Ten-color lithograph and
screenprint in nine parts
printed from five aluminum
plates and one screen; sheet
74 × 95
Edition of 35
Published by Cirrus Editions
Ltd. and Multiples, Inc.,
New York

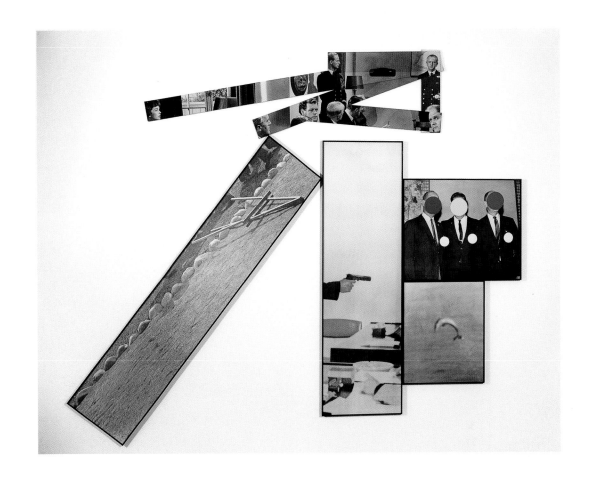

Mel Ramos
(American, b. 1935)
111 *Candy,* from the portfolio
SMS 5, 1968
Offset lithograph on coated
paper, folded in half with
instructions for assembly;
13⅞ × 10⅞ unfolded; finished
sculpture 10 × 2¼ × ¹⁵⁄₁₆
Edition of approximately 2,000
Published by The Letter Edged
in Black Press, New York
Reinhold-Brown Gallery,
New York
© Mel Ramos/Licensed by
VAGA, New York, NY

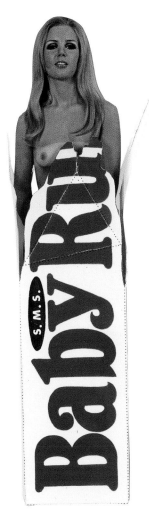

Frank Stella
(American, b. 1936)
112 *Polar Co-ordinates II*, 1980
Lithograph and silkscreen;
38½ × 38
Edition of 100
Published by Petersburg Press,
New York
Courtesy Petersburg Press
© 2000 Frank Stella/Artists
Rights Society (ARS), New York

113 *Talladega Three I*,
from the *Circuits* series, 1982
Etching; 66 × 52
Edition of 30
Published by Tyler Graphics
Ltd., Mount Kisco, New York
Collection Walker Art Center,
Minneapolis
Walker Art Center, Tyler
Graphics Archive, 1984
© 2000 Frank Stella/Tyler
Graphics Ltd./Artists Rights
Society (ARS), New York
Photo: Steven Sloman

Frank Stella

115 *Egyplosis Relief,* from the
Imaginary Places II series, 1996
Relief, etching, and aquatint on
TGL handmade, shaped paper;
31¾ × 31¾ × 1¾
Edition of 36
Published by Tyler Graphics
Ltd., Mount Kisco, New York
Collection Walker Art Center,
Minneapolis
Walker Art Center, Tyler
Graphics Archive, 1984
© 2000 Frank Stella/Tyler
Graphics Ltd./Artists Rights
Society (ARS), New York
Photo: Steven Sloman

114 *Talladega Three II,*
from the *Circuits* series, 1982
Relief on TGL handmade,
hand-colored paper; 66 × 52
Edition of 30
Published by Tyler Graphics
Ltd., Mount Kisco, New York
Collection Walker Art Center,
Minneapolis
Walker Art Center, Tyler
Graphics Archive, 1984
© 2000 Frank Stella/Tyler
Graphics Ltd./Artists Rights
Society (ARS), New York
Photo: Steven Sloman

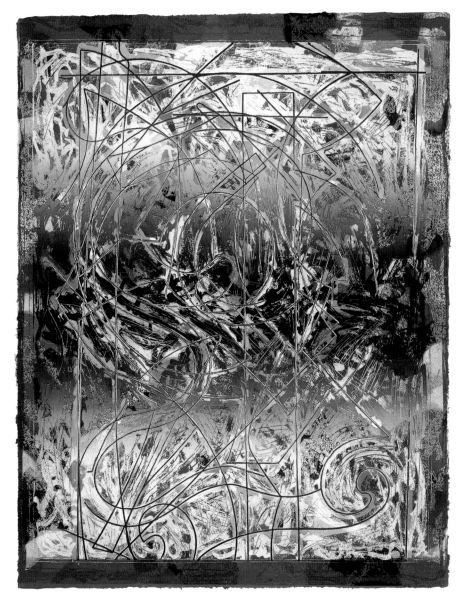

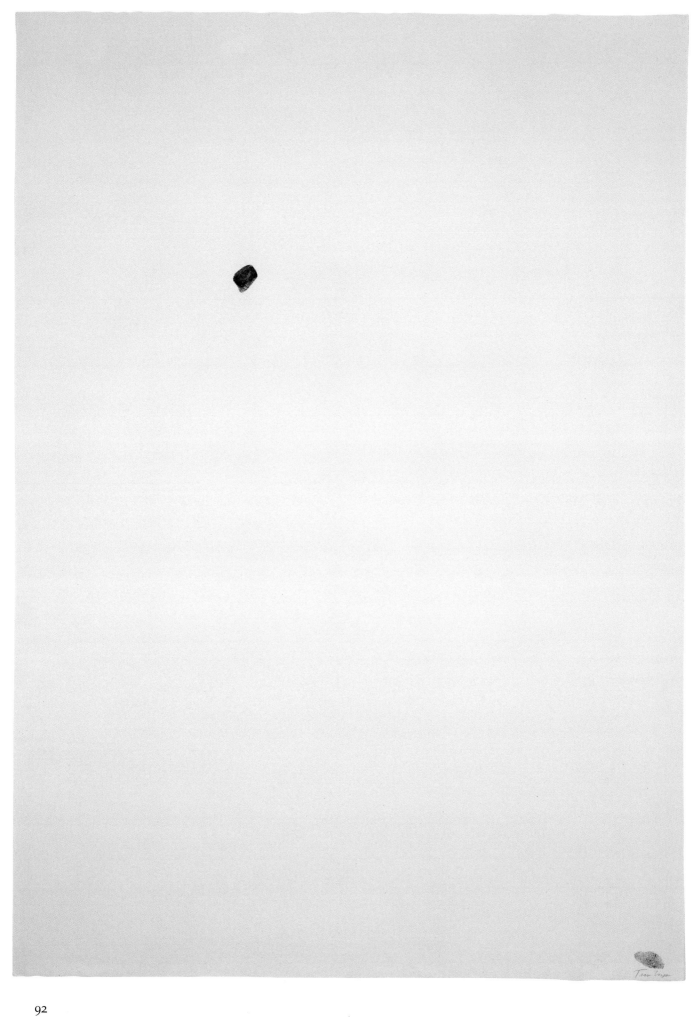

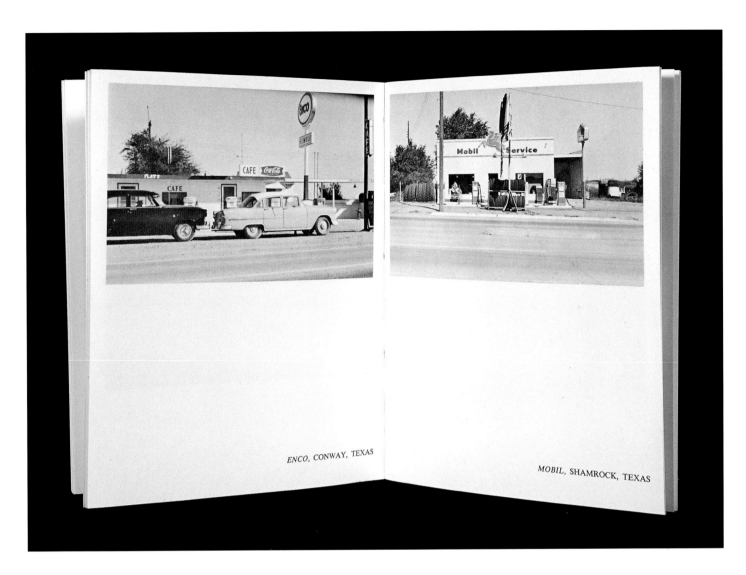

ENCO, CONWAY, TEXAS

MOBIL, SHAMROCK, TEXAS

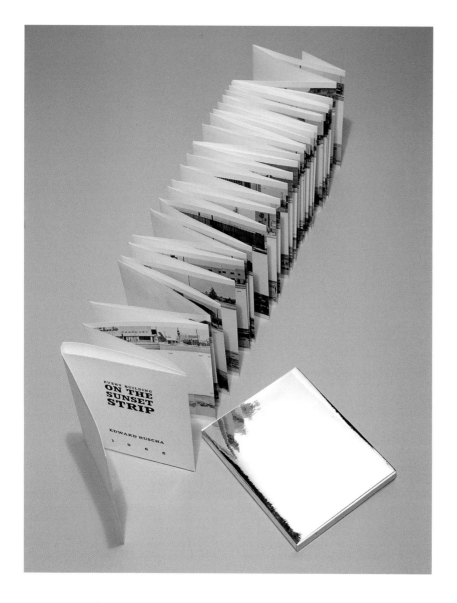

Edward Ruscha
117 *Every Building on the Sunset Strip*, 1966
Accordian-fold book with two continuous motorized photographs, boxed in mylar-covered case; offset lithography; 7¹⁄₁₆ × 5½; extended 7¹⁄₁₆ × 299½
Edition of 1,000
Published by the artist
Collection of the artist
© Edward Ruscha
Photo: Paul Ruscha

118 *Stains,* 1969
Seventy-five stains on rag-paper sheets, one on waterfall-silk slipcase lining; sheets each 11⅞ × 10¾; slipcase 12½ × 11¾
Edition of 70
Published by the artist
Collection of the artist
© Edward Ruscha
Photo: Paul Ruscha

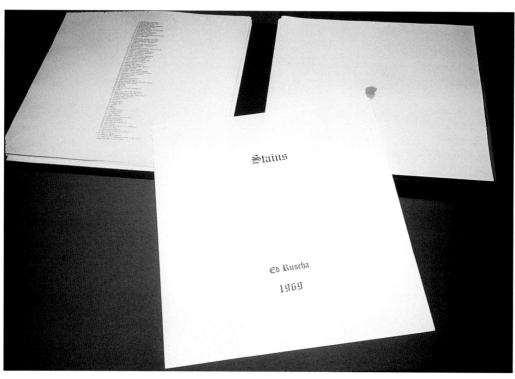

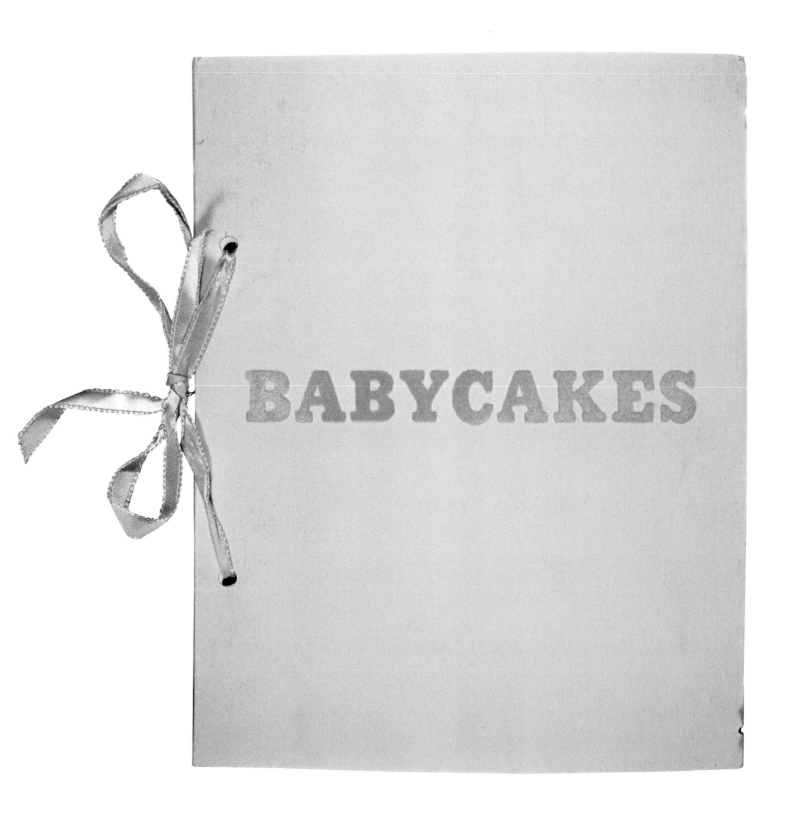

Edward Ruscha
119 *Babycakes with Weights,* 1970
Book, 52 pages with twenty-two
illustrations; offset lithography
with flocked cover bound with
pink ribon; 7⁹⁄₁₆ × 6¹⁄₁₆
Edition of 1,200
Published by Multiples, Inc.,
New York
Collection of the artist
© Edward Ruscha
Photo: Paul Ruscha

Richard Serra
(American, b. 1939)
120 *Double Black,* 1990
Paintstick on handmade
Japanese paper, two panels;
73 × 133
Edition of 20
Published by Gemini G.E.L.,
Los Angeles
© 2000 Richard Serra and
Gemini G.E.L., Los Angeles/
Artists Rights Society (ARS),
New York

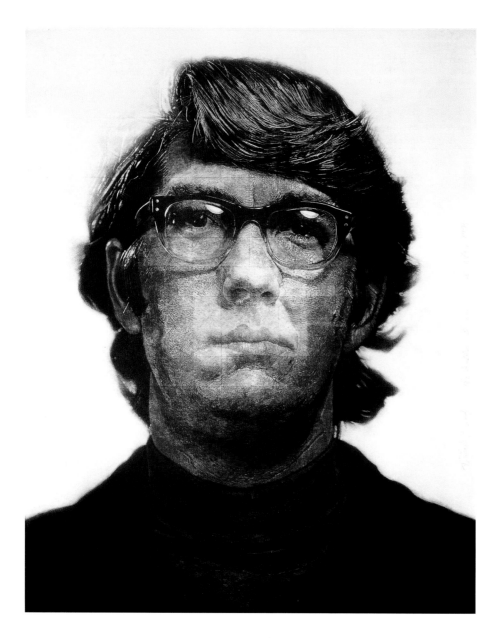

Chuck Close
(American, b. 1940)
121 *Trial Proof for Keith,* 1972
Mezzotint; sheet 48⁷⁄₁₆ × 42¼;
image 44¹³⁄₁₆ × 35¾
Fine Arts Museums of San
Francisco
Crown Point Press Archive
Museum purchase, bequest of
Whitney Warren Jr. in memory
of Mrs. Adolph B. Spreckels
(1991.28.98)

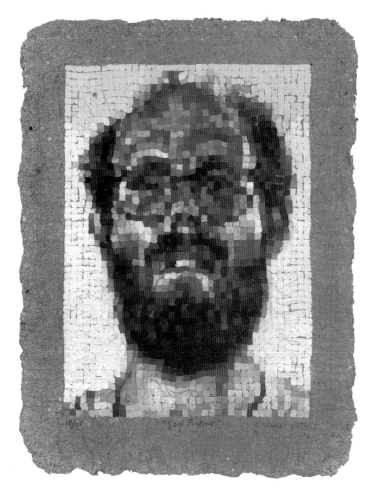

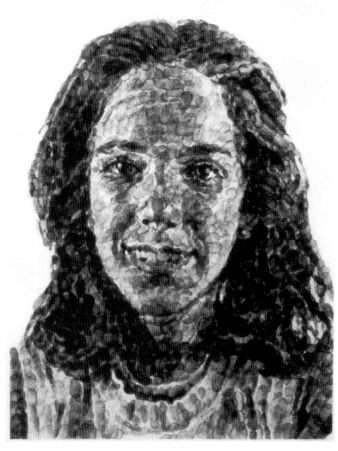

Chuck Close

ABOVE LEFT:
122 *Self-Portrait Manipulated,*
1982
Handmade from colored paper
pulp; 38½ × 28½
Edition of 25
Published by Pace Editions,
Inc., New York
Photo: John Back

ABOVE RIGHT:
123 *Georgia/Fingerprint*
(State II), 1985
Direct gravure etching, state 2;
30 × 22
Edition of 35
Published by Pace Editions,
Inc., New York
Photo: John Back

RIGHT:
124 *Leslie*, 1986
Color woodcut; 30 × 25¼
Edition of 150
Published by Crown Point
Press, San Francisco
Courtesy Crown Point Press

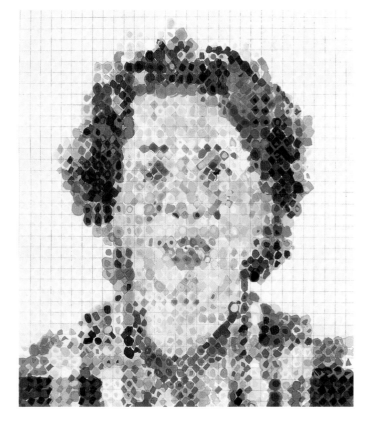

Richard Tuttle
(American, b. 1941)
125 *Print*, 1976
Screenprint in black on two
sheets of handmade paper;
sheets each 31¼ × 22½
Edition of 31
Published by Brooke Alexander
Editions, New York
Photo: Bill Orcutt

Lawrence Weiner
(American, b. 1942)
126 *Statements,* 1968
Book, 64 pages; offset lithog-
raphy with glued binding;
7 × 4
Edition of 1,000
Published by Seth
Siegelaub/The Louis Kellner
Foundation, New York
Collection of Moved Pictures,
New York
© 2000 Lawrence Weiner/
Artists Rights Society (ARS),
New York

127 *Green as Well as Blue as Well
as Red,* 1972
Book, 100 pages; offset lithog-
raphy with sewn binding;
6⅞ × 4⅝
Edition of 1,000
Published by Jack Wendler
Gallery, London
Collection of Moved Pictures,
New York
© 2000 Lawrence Weiner/
Artists Rights Society (ARS),
New York

128 *Pertaining to a Structure,*
1977
Book, 104 pages; offset lithog-
raphy with glued binding;
7 × 4¾
Edition of 750–1,000
Published by Robert Self
Publications, London
Collection of Moved Pictures,
New York
© 2000 Lawrence Weiner/
Artists Rights Society (ARS),
New York

Joseph Kosuth
(American, b. 1945)
129 *Titled (Art as Idea as Idea),*
from the portfolio *SMS* 3, 1968
Four handfolded sheets, each
numbered and titled "Titled
(Art as Idea as Idea)"; each
sheet contains an entry from
four different dictionaries for
the word "abstract" and all are
enclosed in an envelope; each
sheet 19¹⁵⁄₁₆ × 19⅞ (unfolded);
envelope 10⅜ × 10½
Edition of 2,000
Published by The Letter Edged
in Black Press, New York
Reinhold-Brown Gallery,
New York

Richard Long
(British, b. 1945)
130 *Papers of River Muds,* 1990
Bound volume of 12 folded
sheets, each made with mud
from a different river, with text
silkscreened in red; 14 × 11¾ ×
⅞; each sheet 13½ × 11¼
Edition of 88
Published by Lapis Press,
Los Angeles
Spencer Collection
The New York Public Library,
Astor, Lenox and Tilden
Foundations

Chris Burden
(American, b. 1946)
131 *Diecimila*, 1977
Color photoetching printed on
both sides of the sheet; 10 × 14
Edition of 35
Published by Crown Point
Press, San Francisco
Fine Arts Museums of San
Francisco
Crown Point Press Archive
Museum purchase, bequest of
Whitney Warren Jr. in memory
of Mrs. Adolph B. Spreckels
(1991.28.221 r–v)

Recto

Verso

Not Vital
(Swiss American, b. 1948)
132 *Kiss*, 1996
Lift-ground aquatint from two
lambs coated with lift-ground
solution and pressed onto a
copper plate, with additional
painting; sheet 34 × 64;
plate 30 × 60
Edition of 28
Published by Baron/Boisanté
Editions, New York

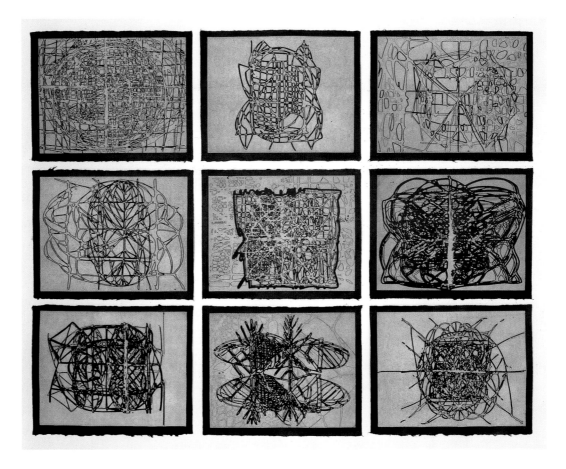

Terry Winters
(American, b. 1949)
133 *Graphic Primitives*, 1998
Portfolio of nine woodcuts
on Japanese Kochi paper;
sheet 20 × 26; image 18 × 24
Edition of 35
Courtesy Matthew Marks
Gallery, New York

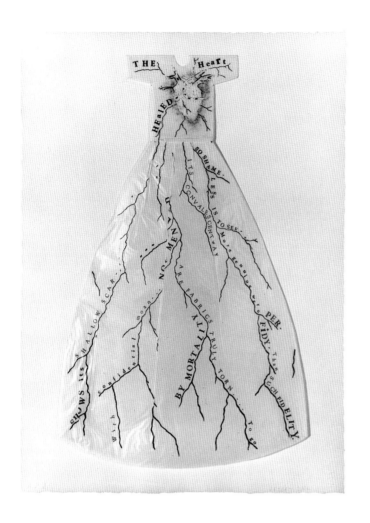

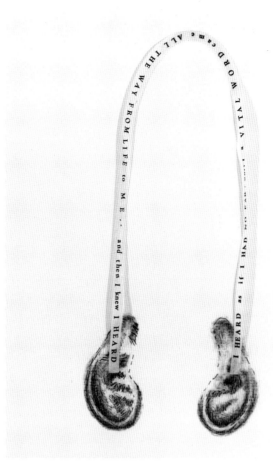

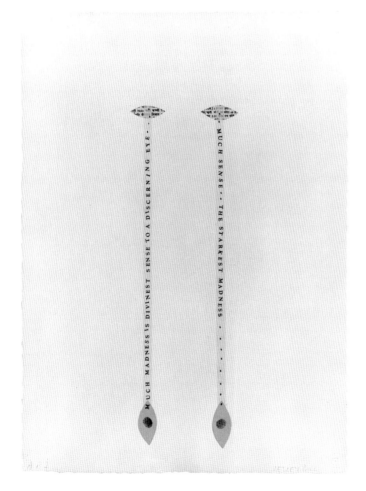

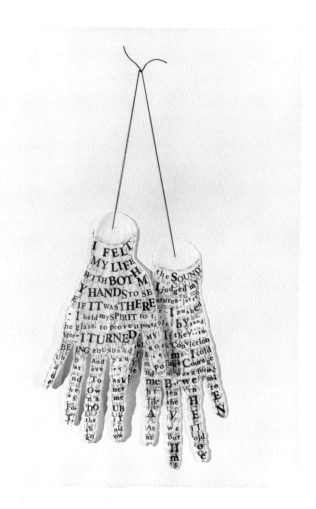

OPPOSITE:
Lesley Dill
(American, b. 1950)
134 *Poem Dress of Circulation,*
from *The Poetic Body,* 1992
Lithograph, letterpress, and
collage; 18 × 13
Edition of 20
Published by Solo Impression,
Inc., New York
Photo: John Back

135 *Poem Ears,*
from *The Poetic Body,* 1992
Lithograph, letterpress, and
collage; 18 × 13
Edition of 20
Published by Solo Impression,
Inc., New York
Photo: John Back

136 *Poem Eyes,*
from *The Poetic Body,* 1992
Lithograph, letterpress, and
collage; 18 × 13
Edition of 20
Published by Solo Impression,
Inc., New York
Photo: John Back

137 *Poem Gloves,*
from *The Poetic Body,* 1992
Lithograph, letterpress, and
collage; 18 × 13
Edition of 20
Published by Solo Impression,
Inc., New York
Photo: John Back

ABOVE:
Francesco Clemente
(Italian, b. 1952)
138 *Untitled (Self-Portrait),* 1984
Color woodcut; 16¾ × 22½
Edition of 200
Published by Crown Point
Press, San Francisco
Fine Arts Museums of San
Francisco
Crown Point Press Archive
Gift of Crown Point Press
(1991.28.2)

Ronald Jones
(American, b. 1952)
139 *Jesus Built My Hot Rod*, 1992
Photogravure; 20 × 40
Edition of 50
Gravure plate by Deli Sacilotto,
Iris Editions, New York
Published by Serena + Warren,
Inc., New York
Private collection, New York
Photo: © 2000 D. James Dee

Peter Halley
(American, b. 1953)
140 *Superdream Mutation*, 1993
Unlimited on-line edition of
digital image
Published by The Thing, Inc.
© The Thing, Inc., and the artist

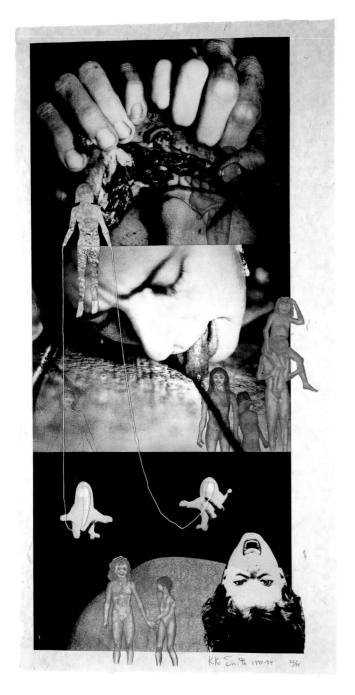

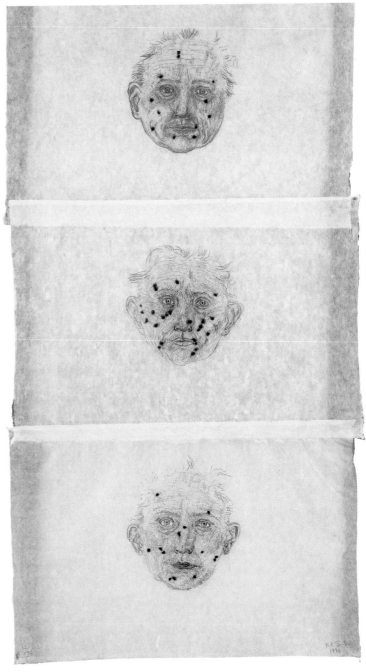

Kiki Smith
(American, b. 1954)
141 *Puppet*, 1993–94
Intaglio; 58 × 29
Edition of 35
Published by Universal
Limited Art Editions, West Islip,
New York
© Kiki Smith and Universal
Limited Art Editions

142 *Constellations*, 1996
Lithograph in colors with
flocking; 57½ × 31
Edition of 42
Published by Universal
Limited Art Editions, West Islip,
New York
© Kiki Smith and Universal
Limited Art Editions

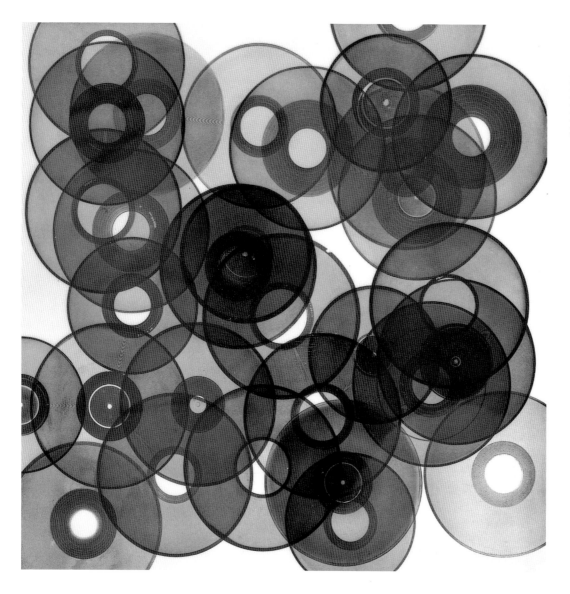

Christian Marclay
(Swiss American, b. 1955)
143 *Monotype,* 1990
Relief print; 45 × 45
Edition of 4
Published by Solo Impression,
Inc., New York
Photo: John Back

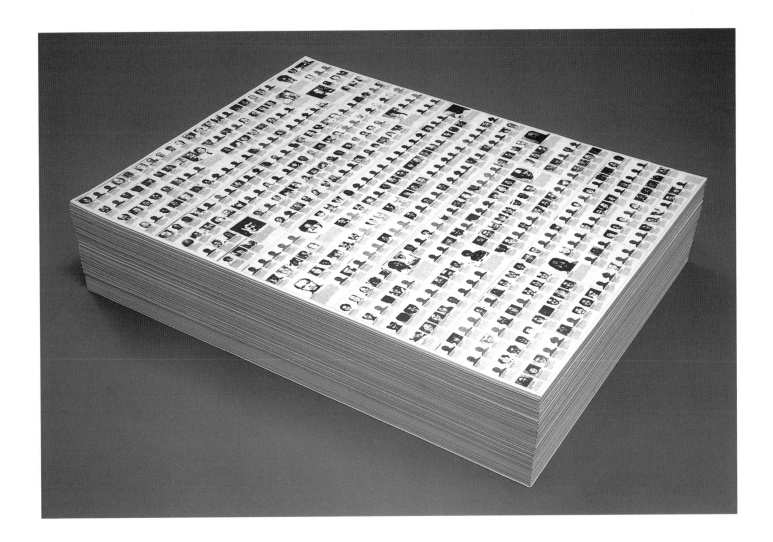

Felix Gonzalez-Torres
(American, 1957–1996)
144 *Untitled (Death by Gun)*,
1990
Nine-inch stack of photolithographs, photo-offset printed in
black; 44½ × 32½
Unique sculpture consisting
of an unlimited edition of
individual sheets printed on
demand
The Museum of Modern Art,
New York
Purchased in part with funds
from Arthur Fleischer, Jr. and
Linda Barth Goldstein
Photo: © 2000 The Museum of
Modern Art, New York

Detail of Felix Gonzalez-
Torres's *Untitled (Death by Gun)*

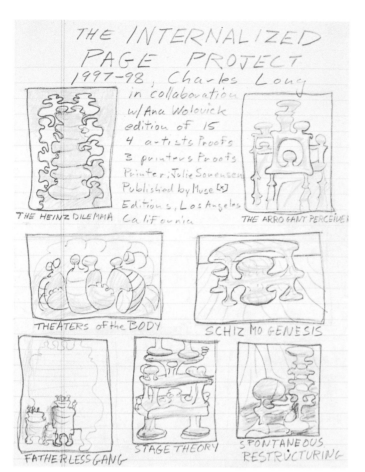

Charles Long
(American, b. 1958) in collaboration with Ana Wolovick
(American Australian, b. 1973)
145 *The Internalized Page Project,* volume 1, 1997–98
Portfolio with seven Iris prints including a title page and six prints labeled "Theatres of the Body," "Stage Theory," "The Arrogant Perceiver," "Spontaneous Restructuring," "Schimogenesis," and "The Heinz Dilemma"; each 11 × 8½
Edition of 15
Published by Muse [X] Editions, Los Angeles
© 2000 Charles Long

George Maciunas/
Fluxus Collective
(established 1962)
146 *Fluxkit*, 1965/66
Fluxus edition; Vinyl attaché
case containing work by twelve
artists in diverse media and
Fluxus publications; 11⅞ ×
17⅜ × 4⅞ (closed)
Unlimited edition
The Gilbert and Lila Silverman
Fluxus Collection, Detroit

147 *Fluxus 1*, ca. 1964
Fluxus edition; Wood box
containing works by twenty-
four artists in diverse media
and Fluxus publications; 8¾ ×
9½ × 2 (closed)
Unlimited edition
The Gilbert and Lila Silverman
Fluxus Collection, Detroit

148 *Flux Year Box 2*, 1966–
ca. 1968
Fluxus edition; Wood box
containing works by twenty-
four artists in diverse media
and Fluxus publications; 8 ×
8 × 3⅜ (closed)
Unlimited edition
The Gilbert and Lila Silverman
Fluxus Collection, Detroit

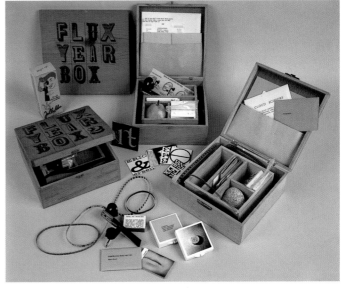

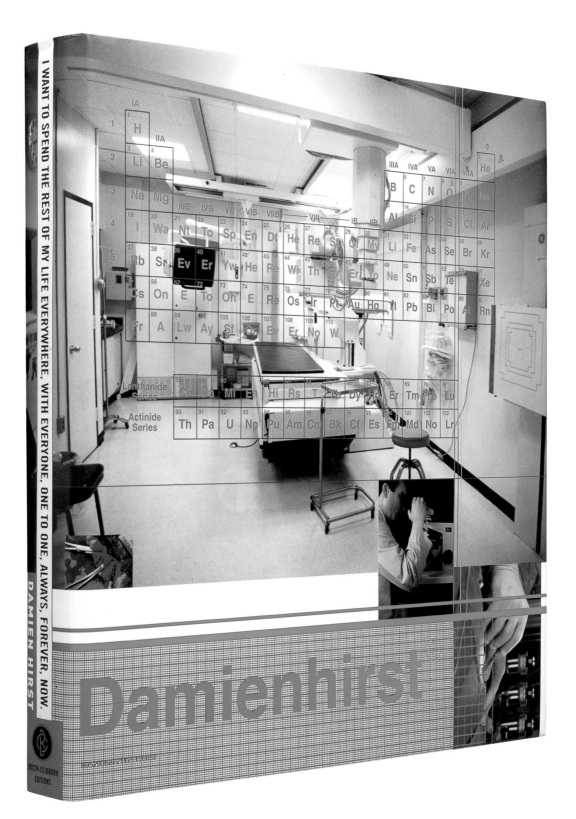

Damien Hirst
(British, b. 1965)
149 *I Want to Spend the Rest of My Life Everywhere, With Everyone, One to One, Always, Forever, Now,* 1997
Book, 334 pages with 700 illustrations, including gatefolds, die cuts, and pop-ups; offset lithography with cloth binding and paper dust jacket; artist's number 89520368721125136852; 11½ × 13
Edition of approximately 10,000
Published by Monacelli Press, New York, and Booth-Clibborn Editions, London

Bibliography

Ackley, Clifford S. *Printmaking in the Age of Rembrandt.* Boston: Museum of Fine Arts, 1981.

Ackley, Clifford S., Timothy O. Benson, and Victor Carlson. *Nolde: The Painter's Prints.* Boston: Museum of Fine Arts, 1995.

Acton, David. *A Spectrum of Innovation.* New York and London: W. W. Norton, 1990.

Applewhite, E. J. *Synergetics Dictionary: The Mind of Buckminster Fuller.* New York: Garland, 1986.

Appuhn, Horst, and Christian von Heusinger. "Der Fund Kleiner Andachtsbilder des 13. bis 17. Jahrhunderts in Kloster Wienhausen." *Niederdeutsche Beiträge zur Kunstgeschichte* 4 (1965): 157–238.

Armstrong, Richard. *Richard Artschwager.* New York: W. W. Norton for the Whitney Museum of American Art, 1988.

Augikos, Jan, Susan Cahan, and Tim Rollins. *Felix Gonzalez-Torres.* Los Angeles: Art Resources Transfer, 1993.

Auping, Michael. *Francesco Clemente.* New York: Harry N. Abrams for the John and Mable Ringling Museum of Art, Sarasota, Fla., 1985.

Axsom, Richard H. *The Prints of Frank Stella: A Catalogue Raisonné, 1967–1982.* New York: Hudson Hills Press in association with the University of Michigan Museum of Art, Ann Arbor, 1983.

Axsom, Richard H., and David Platzker. *Printed Stuff: Prints, Posters, and Ephemera by Claes Oldenburg: A Catalogue Raisonné, 1958–1996.* New York: Hudson Hills Press in association with the Madison Art Center, 1997.

Bartsch, Adam von. *Le peintre graveur.* 20 vols. Vienna: J. V. Degen, 1803–21.

———. *Anleitung zur Kupferstichkunde.* Vienna: J. B. Wallishausser, 1821.

Bénédite, Léonce. *Catalogue des lithographies originales de Henri Fantin-Latour.* Paris: Librairies-Imprimeries Réunies, 1899.

Bernadac, Marie-Laure, and Hans-Ulrich Obrist. *Destruction of the Father, Reconstruction of the Father: Writings and Interviews, 1923–1997/Louise Bourgeois.* London: Violette, 1998.

Bindman, David. *The Complete Graphic Works of William Blake.* New York: G. P. Putnam's Sons, 1978.

Black, Peter, and Désirée Moorhead. *The Prints of Stanley William Hayter: A Complete Catalogue.* Mount Kisco, N.Y.: Moyer Bell, 1992.

Bonk, Ecke. *Marcel Duchamp: The Box in a Valise de ou par Marcel Duchamp ou Rose Selavy: Inventory of an Edition.* New York: Rizzoli, 1989.

Boorsch, Suzanne, and Michal and R. E. Lewis. *The Engravings of Giorgio Ghisi.* New York: The Metropolitan Museum of Art, 1985.

Bosse, Abraham. *Traicté des manières de graver en taille douce sur l'airin: Par le moyen des eaux fortes, et des vernix durs et mols.* Paris: Abraham Bosse, 1645.

Bosse, Abraham, and Charles-Nicolas Cochin. *De la manière de graver à l'eau forte et au burin et de la gravure en manière noire: Avec la façon de construire les presses modernes et d'imprimer en taille-douce: . . . Nouvelle édition, augmentée de l'impression qui imite les tableaux, de la gravure en manière de crayon, et de celle qui imite le lavis.* Paris: Charles-Antoine Jombert, 1745.

Boswell, Peter W., Bruce Jenkins, and Joan Rothfuss. *2000 BC: The Bruce Conner Story Part II.* Minneapolis: Walker Art Center, 1999.

Bruce Conner: Inkblot Drawings, Engraving, Collages. Los Angeles: Kohn Turner Gallery, 1997.

Brundage, Susan, ed. *Technique and Collaboration in the Prints of Jasper Johns.* New York: Leo Castelli Gallery, 1996.

Buchloh, Benjamin H. D. *Posters: November 1965–April 1986/Lawrence Weiner.* Halifax: Press of the Nova Scotia College of Art and Design; Toronto: Art Metropole, 1986.

Bury, Michael. "The Taste for Prints in Italy." *Print Quarterly* 2, no. 1 (1985): 12–26.

Carley, Michal Ann. "Lesley Dill's Use of Language: The Artist Strings Line into Letter and Letter into Text." *Fiberarts* 26, no. 1 (summer 1999): 32–36.

Carlson, Victor I., John Ittmann, et al. *Regency to Empire: French Printmaking, 1715–1814.* Minneapolis: Minneapolis Institute of Arts, 1984.

Castleman, Riva. *Jasper Johns: A Print Retrospective.* New York: Museum of Modern Art, 1986.

Claes Oldenburg: Multiples in Retrospect, 1964–1990. New York: Rizzoli, 1991.

Claes Oldenburg: The Multiples Store. London: South Bank Centre, 1996.

Cole, Alphaeus Philemon. *Timothy Cole: Wood-Engraver.* New York: Pioneer Associates, 1935.

Colombo, Paolo, et al. *Kiki Smith.* Amsterdam: Institute of Contemporary Art, 1990.

Corlett, Mary Lee. *The Prints of Roy Lichtenstein: A Catalogue Raisonné, 1948–1993.* New York: Hudson Hills Press in association with the National Gallery of Art, Washington, D.C., 1994.

Crone, Rainer, and Georgia Marsh. *Clemente.* New York: Vintage Books, 1987.

Czestochowski, Joseph S. *Arthur B. Davies: A Catalogue Raisonné of the Prints.* Newark: University of Delaware Press, 1987.

Damien Hirst: The Acquired Inability to Escape Divided the Acquired Inability to Escape Inverted and Divided and Other Works. Cologne: Jablonka Galerie, 1993.

Delteil, Loys. *Le peintre-graveur illustré.* 32 vols. Paris: Delteil, 1906–30.

Dennison, Lisa. *Roy Lichtenstein.* New York: Solomon R. Guggenheim Museum, 1993.

——. *Clemente.* New York: Solomon R. Guggenheim Museum, 1999.

DePauw, Carl, and Ger Luijten. *Anthony van Dyck as a Printmaker.* New York: Rizzoli, 1999.

Dill, Lesley. "Dada Poem Wedding Dress." *Art Journal* 54 (spring 1995): 84–85.

Donat, John, Norman Foster, and Dennis Sharp. "Buckminster Fuller." *Architects' Journal* 202 (December 14, 1995): 21–26.

Drolet, Owen. "Columbia's Digital Media Center: A Conversation with Ronald Jones." *Flash Art* 199 (March/April 1998): 56.

Dupin, Jacques. *Miro graveur.* 3 vols. Paris: Daniel Lelong, 1984–91.

Dussler, Luitpold. *Die Incunabeln der deutschen Lithographie (1796–1821).* Berlin: H. Tiedemann, 1925.

Edgren, Sören. *Chinese Rare Books in American Collections.* New York: China House Gallery, China Institute in America, 1984.

Eisler, Colin T. *The Master of the Unicorn: The Life and Work of Jean Duvet.* New York: Abaris Books, 1977.

Elger, Dietmar. *Felix Gonzalez-Torres.* Stuttgart: Cantz, 1997.

Emison, Patricia. "Prolegomenon to the Study of Italian Renaissance Prints." *Word and Image* 11 (January/March 1995): 1–15.

Engberg, Siri. *Frank Stella at Tyler Graphics.* Minneapolis: Walker Art Center, 1997.

Engberg, Siri, and Clive Phillpot. *Edward Ruscha: Editions, 1959–1999.* New York: D.A.P. for the Walker Art Center, Minneapolis, 1999.

Evelyn, John. *Sculptura, or, The History and Art of Chalcography.* London: G. Beedle, T. Collins, and J. Crook, 1662.

Feinstein, Roni. *Robert Rauschenberg: The Silkscreen Paintings, 1962–64.* New York: Whitney Museum of American Art, 1990.

Feldman, Frayda, and Jörg Schellmann. *Andy Warhol Prints: A Catalogue Raisonné, 1962–1987.* New York: D.A.P. in association with Ronald Feldman Fine Arts, 1997.

Ferguson, Russell, ed. *Felix Gonzalez-Torres.* Los Angeles: Museum of Contemporary Art, 1994.

Field, Richard S. *Fifteenth-Century Woodcuts and Metalcuts from the National Gallery of Art.* Washington, D.C.: National Gallery of Art, 1965.

——. *Jasper Johns: Prints, 1970–1977.* Middletown, Conn.: Wesleyan University, 1978.

——. *The Prints of Jasper Johns, 1960–1993: A Catalogue Raisonné.* West Islip, N.Y.: Universal Limited Art Editions, 1994.

Figura, Starr. *Peter Halley.* New York: Museum of Modern Art, 1997.

——. *A Project for MoMA Magazine: Peter Halley.* New York: Museum of Modern Art, 1997.

Flint, Janet. *Provincetown Printers: A Woodcut Tradition.* Washington, D.C.: Smithsonian Institution Press for the National Museum of American Art, 1983.

Flood, Richard. *Ronald Jones.* Cologne: Galerie Isabella Kacprzak, 1990.

Foirades/Fizzles: Echo and Allusion in the Art of Jasper Johns. Los Angeles: Grunwald Center for the Graphic Arts and Wight Art Gallery, University of California, Los Angeles, 1987.

Forrer, Robert. *Die Zeugdrucke der byzantinischen, romanischen, gothischen und späteren Kunstepochen.* Strasbourg, 1894.

——. *Die Kunst des Zeugdrucks vom Mittelalter bis zur Empirezeit.* Strasbourg, 1898.

Forster, Kurt W. "Authentic Imitations of Genuine Replicas." *Parkett* 46 (May 1996): 44–55.

Frank Stella: Prints, 1967–1982. New York: Whitney Museum of American Art, 1983.

Fryberger, Betsy G. *Picasso, Graphic Magician: Prints from the Norton Simon Museum.* London: Iris and Gerald B. Cantor Center for Visual Arts at Stanford University in association with Philip Wilson Publishers, 1999.

Fuller, R. Buckminster. *Tetrascroll: Goldilocks and the Three Bears: A Cosmic Fairy Tale.* West Islip, N.Y.: Universal Limited Art Editions; New York: St. Martin's Press, 1982.

——. *The Artifacts of R. Buckminster Fuller: A Comprehensive Collection of His Designs and Drawings.* New York: Garland, 1985.

Garrels, Gary. *Robert Ryman.* New York: Dia Art Foundation, 1988.

——. *Sol LeWitt: A Retrospective.* New Haven: Yale University Press for the San Francisco Museum of Modern Art, 2000.

Gascoigne, Bamber. *How to Identify Prints.* New York: Thames and Hudson, 1986.

Geelhaar, Christian. *Jasper Johns: Working Proofs.* London: Petersburg Press, 1980.

Gelder, Dirk van. *Les huit eaux-fortes de Rodolphe Bresdin reportées sur pierre: Une reconstruction.* Amsterdam, 1969.

——. *Rodolphe Bresdin.* The Hague: Martinus Nijhoff, 1976.

Gilmour, Pat, ed. *Lasting Impressions: Lithography as Art.* Philadelphia: University of Pennsylvania Press, 1988.

Glassman, Elizabeth, and Marilyn F. Symmes. *Cliché-verre: Hand-Drawn, Light-Printed — A Survey of the Medium from 1839 to the Present.* Detroit: Detroit Institute of Arts, 1980.

Godfrey, Richard T. *Printmaking in Britain: A General History from Its Beginnings to the Present Day.* New York: New York University Press, 1978.

Goldman, Judith. *Frank Stella: Fourteen Prints, with Drawings, Collages, and Working Proofs.* Princeton, N.J.: Princeton University Art Museum, 1983.

Goldstein, Ann. *Dieter Roth.* Chicago: Museum of Contemporary Art, 1984.

Graphische Sammlung Albertina. *Parmigianino und sein Kreis: Zeichnungen und Druckgraphik aus eigenem Besitz.* Vienna: Graphische Sammlung Albertina, 1963.

Griffiths, Antony. "Notes on Early Aquatint in England and France." *Print Quarterly* 4, no. 3 (1987): 255–70.

——. *Prints and Printmaking: An Introduction to the History and Techniques.* Berkeley and Los Angeles: University of California Press, 1996.

Guare, John. *Chuck Close: Life and Work, 1988–1995.* New York: Thames and Hudson in association with Yarrow Press, 1995.

Guberman, Sidney. *Frank Stella: Imaginary Places.* Mount Kisco, N.Y.: Tyler Graphics, 1995.

Guérin, Marcel. *L'oeuvre gravé de Gauguin.* Paris: H. Floury, 1927.

Güse, Ernst-Gerhard, and Yves Alain Bois. *Richard Serra.* New York: Rizzoli, 1988.

Halley, Peter. *Peter Halley: Collected Essays, 1981–1987.* Zurich: Bruno Bischofberger Gallery; New York: Sonnabend Gallery, 1989.

——. *Peter Halley: Recent Essays, 1990–1996.* New York: Edgewise, 1997.

Harris, Susan. *Richard Tuttle.* Amsterdam: Institute of Contemporary Art; The Hague: SDU Publishers, 1991.

Harris, Tomás. *Goya: Etchings and Lithographs.* Oxford: B. Cassirer, 1964.

Haverkamp-Begemann, Egbert. *Willem Buytewech.* Amsterdam: Menno Hertzberger, 1959.

——. *Hercules Segers: The Complete Etchings.* Amsterdam: Scheltema and Holkema; The Hague: Martinus Nijhoff, 1973.

Hayes, John. *Gainsborough as Printmaker.* New Haven: Yale University Press, 1972.

Hayter, Stanley William. *New Ways of Gravure.* New York: Pantheon, 1949.

Heinecken, Karl Heinrich von. *Idée générale d'une collection complète d'estampes avec une dissertation sur l'origine de la gravure et sur les premiers livres d'images.* Leipzig and Vienna: Jean Paul Kraus, 1771.

Hickey, Dave, and Peter Plagens. *The Works of Edward Ruscha.* New York: Hudson Hills Press in association with the San Francisco Museum of Modern Art, 1982.

Hind, A. M. *A Short History of Engraving and Etching.* London: Constable and Company, 1923.

——. *An Introduction to a History of Woodcut.* London: B. Quaritch, 1935.

——. *Early Italian Engraving: A Critical Catalogue with Complete Reproduction of All the Prints Described.* 7 vols. London: B. Quaritch, 1938–48.

Hirst, Damien. *I Want to Spend the Rest of My Life Everywhere, with Everyone, One to One, Always, Forever, Now.* London: Booth-Clibborn Editions, 1997.

Hoffman, Edith Warren. "Some Engravings Executed by the Master E. S. for the Benedictine Monastery at Einsiedeln." *The Art Bulletin* 63 (September 1961): 231–37.

Hollstein, F. W. H. *Dutch and Flemish Etchings, Engravings, and Woodcuts, ca. 1450–1700.* Amsterdam: M. Hertzberger, 1949–.

——. *German Engravings, Etchings, and Woodcuts, ca. 1400–1700.* Amsterdam: M. Hertzberger, 1954–.

Hoppe-Sailer, Richard, and Mark Demming. *Richard Serra: das druckgraphische Werk, 1972–1988.* Bochum: Galerie für Film, Foto, Neue Konkrete Kunst und Video, 1988.

Hopps, Walter. *Robert Rauschenberg: The Early 1950s.* Houston: The Menil Collection and Houston Fine Art Press, 1991.

———. *Robert Rauschenberg: A Retrospective.* New York: Solomon R. Guggenheim Museum, 1997.

Hults, Linda C. *The Print in the Western World: An Introductory History.* Madison: University of Wisconsin Press, 1997.

Humbert, Abraham von. *Abrégé historique de l'origine et des progrez de la gravure et des estampes en bois, et en taille douce.* Berlin: Chez Haude und Spener, 1752.

Hunisett, Basil. *Engraved on Steel: The History of Picture Production Using Steel Plates.* Aldershot, Hants, Great Britain: Ashgate Publishing, 1998.

Hutchison, Jane. "The Housebook Master and the Folly of the Wise Man." *The Art Bulletin* 48 (March 1966): 73–78.

Ivins, William M., Jr. *Prints and Visual Communication.* Cambridge: Harvard University Press, 1953.

———. *How Prints Look.* Boston: Beacon Press, 1987.

Jansen, Hendrick. *Essai sur l'origine de la gravure en bois et en taille-douce, et sur la connoissance des estampes.* Paris: F. Schoell, 1808.

Janssen, Hans. *Richard Serra: Drawings, 1969–1990: Catalogue Raisonné/Zeichnungen, 1969–1990: Werkverzeichnis.* Bern: Benteli, 1990.

John Cage: Etchings, 1978–1982. Oakland, Calif.: Point Publications, 1982.

Katz, Vincent. "John Cage: An Interview." *Print Collector's Newsletter* 20 (January/February 1990): 204–9.

———. "Interview with Christian Marclay." *Print Collector's Newsletter* 22 (March/April 1991): 5–9.

Kellein, Thomas. *Not Vital.* New York: D.A.P., 1996.

Kennedy, Edward G. *Catalogue of Etchings by J. McN. Whistler.* New York: H. Wunderlich and Company, 1902.

Kiki Smith: Unfolding the Body: An Exhibition of the Work in Paper. Waltham, Mass.: Rose Art Museum, Brandeis University, 1992.

King, Donald. "Textiles and the Origins of Printing in Europe." *Pantheon: Internationale Zeitschrift für Kunst* 20, no. 1 (January–February 1962): 23–30.

Knab, Eckhart. *Jacques Callot und sein Kreis: Werke aus dem Besitz der Albertina und Leihgaben aus den Uffizien.* Vienna: Graphische Sammlung Albertina, 1968.

Koehler, S. R. *Etching: An Outline of Its Technical Processes and Its History with Some Remarks on Collections and Collecting.* New York: Cassell and Company, 1885.

Körner, Hans. *Der früheste deutsche Einblattholzschnitt.* Mittenwald: Mäander Kunstverlag, 1979.

Krakow, Barbara. *Kiki Smith: Prints and Multiples, 1985–1993.* Boston: Barbara Krakow Gallery, 1994.

Kunz, Martin. *Not Vital.* Lucerne: Kunstmuseum, 1988.

Laboureur, Sylvain. *Catalogue complet de l'oeuvre de Jean-Emile Laboureur.* 4 vols. Neuchâtel: Ides et Calendes, 1989–91.

Landau, David, and Peter Parshall. *The Renaissance Print, 1470–1550.* New Haven and London: Yale University Press, 1994.

Larson, Philip. "Working Space, by Frank Stella." *Print Collector's Newsletter* 17 (January/February 1987): 221–23.

Lauf, Cornelia, and Clive Phillpot. *Artists/Author: Contemporary Artists' Books.* New York: D.A.P., 1998.

Laurentius, Th., et al. *Cornelis Ploos van Amstel, 1726–1798: Kunstverzamelaar en prentuitgever.* Assen: Van Gorcum, 1980.

Le Blon, Jakob Christof. "Coloritto, or the Harmony of Colouring in Painting." In [Antoine Gauthier de Mondorge,] *L'art d'imprimer les tableaux: Traité d'après les écrits, les opérations et les instructions verbales, de J. C. Le Blon.* Paris: P. G. Le Mercier, Jean-Luc Nyon, and Michel Lambert, 1791.

Legg, Alicia, ed. *Sol LeWitt.* New York: Museum of Modern Art, 1978.

Lepic, Ludovic Napoléon. "La gravure à l'eau-forte: Essai historique." Pamphlet in S. P. Avery Collection, Miriam and Ira D. Wallach Division of Art, Prints and Photographs, The New York Public Library, Astor, Lenox and Tilden Foundations.

Levenson, Jay, Konrad Oberhuber, and Jacquelyn L. Sheehan. *Early Italian Engravings from the National Gallery of Art.* Washington, D.C.: National Gallery of Art, 1973.

Lewison, Jeremy. *Sol LeWitt: Prints, 1970–86.* London: Tate Gallery, 1986.

Lochnan, Katherine. *Whistler and His Circle: Etchings and Lithographs from the Collection of the Art Gallery of Ontario.* Toronto: Art Gallery of Ontario, 1986.

Lyons, Lisa, and Robert Storr. *Chuck Close.* New York: Rizzoli, 1987.

Mackay, Christine. "An Experiment to Follow the Spirit Aquatint Methods of Paul Sandby." *Print Quarterly* 4, no. 3 (1987): 255–70.

Mari, Bartomeu. *Show (&) Tell: The Films and Videos of Lawrence Weiner: A Catalogue Raisonné.* Ghent: Imschoot, 1992.

McShine, Kynaston. *Andy Warhol: A Retrospective.* New York: Museum of Modern Art, 1989.

Medley-Buckner, Cindy. "Carborundum Mezzotint and Carborundum Etching." *Print Quarterly* 16, no. 1 (1999): 33–49.

Melot, Michel, Antony Griffiths, and Richard S. Field. *Prints: History of an Art.* New York: Skira/Rizzoli, 1981.

Metropolitan Museum of Art. *Picasso Linoleum Cuts: The Mr. and Mrs. Charles Kramer Collection in the Metropolitan Museum of Art.* Introduction by William S. Lieberman; catalogue by L. Donald McVinney. New York: Random House, 1985.

Minott, Charles. *Martin Schongauer.* New York: Collectors Editions, 1971.

Moeglin-Delcroix, Anne. *Esthétique du livre d'artiste, 1960/1980.* Paris: Éditions Jean-Michel Place/ Bibliothèque nationale de France, 1997.

Mongan, Elizabeth, Eberhard W. Kornfeld, and Harold Joachim. *Paul Gauguin: Catalogue Raisonné of His Prints.* Bern: Galerie Kornfeld, 1988.

Moser, Joann. *Atelier 17: A 50th Anniversary Retrospective Exhibition.* Madison: Elvehjem Art Center, University of Wisconsin, 1977.

———. *Singular Impressions: The Monotype in America.* Washington, D.C.: Smithsonian Institution Press for the National Museum of American Art, 1997.

Mourlot, Fernand. *Picasso, lithographe.* 4 vols. Monte Carlo: A. Sauret, 1949–64.

Noteboom, Elinor. "Screen Printing: Where Did It All Begin?" *Screenprinting,* September 1992, 52–122.

———. "Screen Printing in the Advertising Trade: A Historical Perspective." *Screenprinting,* November 1993, 152–91.

Oberhuber, Konrad. *Renaissance in Italien.* Vienna: Graphische Sammlung Albertina, 1966.

Ottley, William Young. *An Inquiry into the Origin and Early History of Engraving upon Copper and in Wood.* London: J. Lilly, 1816.

Panofsky, Erwin. "'Imago Pietatis': Ein Beitrag zur Typengeschichte des 'Schmerzensmanns' und der 'Maria Mediatrix.'" In *Festschrift für Max J. Friedländer zum 60. Geburtstage,* 261–308. Leipzig: E. A. Seemann, 1927.

Papillon, Jean-Michel. *Traité historique et pratique de la gravure en bois.* 2 vols. Paris: P. G. Simon, 1766.

Parris, Leslie. *John Constable and David Lucas.* New York: Salander-O'Reilly Galleries, 1993.

Pauli, Gustav. *Inkunabeln der Deutschen und Niederländischen Radierung.* Berlin: Graphische Gesellschaft, 1908.

Perez Sanchez, Alfonso E., Eleanor A. Sayre, et al. *Goya and the Spirit of the Enlightenment.* Boston: Little, Brown and Company, 1989.

Pernotto, Jim. *Chuck Close: Editions: A Catalog Raisonné and Exhibition.* Youngstown, Ohio: The Butler Institute of American Art, 1989.

Peter Halley. Madrid: Museo Nacional Reina Sofía, 1991.

Phillips, Lisa. *Terry Winters.* New York: Whitney Museum of American Art, 1991.

Plous, Phyllis. *Terry Winters: Painting and Drawing.* Seattle: University of Washington Press for the University Art Museum, University of California, Santa Barbara, 1987.

Posner, Helaine, and David Frankel. *Kiki Smith.* Boston: Little, Brown and Company, 1998.

Prelinger, Elizabeth. *Edvard Munch, Master Printmaker: An Examination of the Artist's Works and Techniques Based on the Philip and Lynn Straus Collection.* New York: W. W. Norton, 1983.

Prideaux, Sarah Treverbian. *Aquatint Engraving: A Chapter in the History of Book Illustration.* London: Duckworth and Company, 1909.

Princenthal, Nancy. "The Afangar Icelandic Series: Serra's Recent Etchings." *Print Collector's Newsletter* 22 (November/December 1991): 158–60.

——. "Numbers of Happiness: Richard Tuttle's Books." *Print Collector's Newsletter* 24 (July/August 1993): 81–96.

——. "Good Vibrations: Ronald Jones' Petrarch's Air and Multiples." *Print Collector's Newsletter* 25 (March/April 1994): 1–5.

——. "Word of Mouth: Lesley Dill's Work on Paper." *On Paper* 2, no. 4 (March/April 1998): 27–31.

Rainwater, Robert. "Signs of Life: Not Vital's Prints and Books." *Print Collector's Newsletter* 23 (July/August 1992): 81–87.

Rainwater, Robert, and Robert M. Murdock. *Richard Tuttle: Books and Prints.* New York: New York Public Library, 1997.

Rauschenberg. New York: Vintage Books, 1987.

Reed, Sue Welsh, and Barbara Stern Shapiro. *Edgar Degas: The Painter as Printmaker.* Boston: Little, Brown and Company, 1984.

Reed, Sue Welsh, and Richard Wallace. *Italian Etchers of the Renaissance and Baroque.* Boston: Museum of Fine Arts, 1989.

Reed, Sue Welsh, et al. *French Prints from the Age of the Musketeers.* Boston: Museum of Fine Arts, 1998.

Richard Artschwager. Paris: Cartier Foundation, 1994.

Richard Artschwager: Complete Multiples. Catalogue Raisonné. New York: Brooke Alexander Editions, 1991.

Robertson, Bruce. *The Art of Paul Sandby.* New Haven: Yale Center for British Art, 1985.

Robison, Andrew. *Paper in Prints.* Washington, D.C.: National Gallery of Art, 1977.

Rodari, Florian, Maxime Préaud, et al. *Anatomie de la couleur: L'invention de l'estampe en couleurs.* Paris: Bibliothèque Nationale and Musée Olympique Lausanne, 1996.

Roethlisberger, Marcel. "The Prints of Gerhardt Janssen." *Print Quarterly* 4, no. 3 (1987): 288–95.

Rolywholyover: A Circus. New York: Rizzoli for the Museum of Contemporary Art, Los Angeles, 1993.

Rosand, David, and Michelangelo Muraro. *Titian and the Venetian Woodcut.* Washington, D.C.: International Exhibitions Foundation, 1976.

Rose, Barbara. *Claes Oldenburg.* New York: Museum of Modern Art, 1970.

Rosenfeld, Hellmut. "Wann und wo wurde die Holzschnittkunst erfunden?" *Archiv für Geschichte des Buchwesens* 34 (1990): 327–42.

Roth, Dieter. *Bücher und Grafik (1. Teil): Aus den Jahren 1947 bis 1971.* Stuttgart and London: Edition Hansjörg Mayer, 1972.

——. *Bücher und Graphik (2. Teil) u.a.m.: Aus den Jahren 1971–1979 (und Nachtrag zum 1. Teil).* Stuttgart and London: Edition Hansjörg Mayer, 1979.

Roth, Moira, and Jonathon D. Katz. *Difference/Indifference: Musings on Postmodernism, Marcel Duchamp, and John Cage.* Amsterdam: G+B Arts International, 1998.

Rubin, Lawrence. *Frank Stella: A Catalogue Raisonné.* New York: Stewart, Tabori and Chang, 1986.

Rubin, William S. *Frank Stella.* New York: Museum of Modern Art, 1970.

——. *Frank Stella, 1970–1987.* New York: Museum of Modern Art, 1987.

——. *Picasso and Braque: Pioneering Cubism.* New York: Museum of Modern Art, 1989.

Ruzicka, Joseph. "Drive-By Poetry." *Art in America* 87 (February 1999): 54–57.

Sandby, William. *Thomas and Paul Sandby, Royal Academicians.* London: Seeley and Company, 1892.

Schellmann, Jörg. *Joseph Beuys, The Multiples: Catalogue Raisonné of Multiples and Prints.* 8th ed. New York: D.A.P., 1997.

Schiefler, Gustav. *Edvard Munch: Das graphische Werk, 1906–1926.* Berlin: Euphorion, 1928.

——. *Emil Nolde: Das graphische Werk.* 2 vols. Cologne: DuMont Schauberg, 1966–67.

Schleifer, Kristen-Brooke. "Inside and Out: An Interview with Kiki Smith." *Print Collector's Newsletter* 22 (July/August 1991): 84–87.

Schrijver, Pieter. *Laure-crans voor Laurens Coster van Haerlem.* Haarlem: Adriaen Roman, 1628.

Schwabsky, Barry. "A Meaning Exists That the Outside Is Not Privy To: Lawrence Weiner as a Culture." *Print Collector's Newsletter* 26 (March/April 1995): 1–4.

Schwartz, Paul Wolfgang. *Neue und gründliche Art die Aqua-tinta oder Tuschmanier.* Nuremberg: J. E. Seidel, 1805.

Schwarz, Arturo. *The Complete Works of Marcel Duchamp.* New York: Delano Greenridge Editions, 1997.

Schwarz, Dieter. *Lawrence Weiner: Books, 1968–1989.* Cologne: Verlag Walther König, 1989.

Sellink, Manfred. *Cornelis Cort: Accomplished Plate Cutter from Hoorn in Holland.* Rotterdam: Museum Boymans-van Beuningen, 1994.

Senefelder, Alois. *Vollständiges Lehrbuch der Steindruckerey enthaltend eine richtige und deutliche Anweisung zu den verschiedenen Manipulations-Arten derselben.* Munich: K. Thienemann, 1818.

Shestack, Alan. *Master E. S. Five Hundredth Anniversary Exhibition.* Philadelphia: Philadelphia Museum of Art, 1967.

——. *Fifteenth-Century Engraving of Northern Europe.* Washington, D.C.: National Gallery of Art, 1968.

Shirley, Andrew. *The Published Mezzotints of David Lucas after John Constable.* London: Oxford University Press, 1930.

Shoemaker, Innis H., and Elizabeth Broun. *The Engravings of Marcantonio Raimondi.* Lawrence, Kans.: The Spencer Museum of Art, 1981.

Sickert, Walter. *Down Etching Needle Street: A Free House! or, The Artist as Craftsman.* London: Macmillan, 1947.

Smith, Roberta. *Schema: Terry Winters.* West Islip, N.Y.: Universal Limited Art Editions, 1988.

Sojka, Nancy, and Richard H. Axsom. *Terry Winters: Prints, 1982–1998: A Catalogue Raisonné.* Detroit: Detroit Institute of Arts, 1999.

Sol LeWitt: Books, 1966–1990. Frankfurt: Portikus; Cologne: Verlag Walther König, 1990.

Sol LeWitt: Graphik, 1970–1975. Bern: Verlag Kornfeld und Cie for the Kunsthalle Basel, 1975.

Sparks, Esther. *Universal Limited Art Editions: A History and Catalogue.* New York: Harry N. Abrams, 1989.

Spector, Nancy. *Felix Gonzalez-Torres.* New York: Solomon R. Guggenheim Museum, 1995.

Spring, Justin. "Lesley Dill." *Artforum* 34 (January 1996): 85–86.

Stampfle, Felice, et al. *Rembrandt: Experimental Etcher.* Greenwich, Conn.: New York Graphic Society, 1969.

Stapart, M. *L'art de graver au pinceau.* Paris: Stapart, 1773.

Steiner, Rochelle. *Currents 75: Charles Long.* St. Louis, Mo.: St. Louis Art Museum, 1998.

Stijnman, Ad. "Jan van de Velde IV and the Invention of Aquatint." *Print Quarterly* 8, no. 2 (1991): 153–63.

Stock, Jan van der. *Printing Images in Antwerp: The Introduction of Printmaking in a City, Fifteenth Century to 1585.* Studies in Prints and Printmaking, vol. 2. Rotterdam: Sound and Vision Interactive, 1998.

Storr, Robert. *Robert Ryman.* New York: Museum of Modern Art, 1993.

——. *Chuck Close.* New York: Museum of Modern Art, 1998.

Strauss, Walter L. *Hendrik Goltzius, 1558–1617: The Complete Engravings and Woodcuts.* New York: Abaris Books, 1977.

——, ed. *The Intaglio Prints of Albrecht Dürer.* New York: Abaris Books, 1976.

——, ed. *The Illustrated Bartsch.* 165 vols. New York: Abaris Books, 1978–.

——, ed. *Albrecht Dürer: Woodcuts and Woodblocks.* 2 vols. New York: Abaris Books, 1980.

Stutzer, Beat. *Not Vital: Druckgraphik und Multiples.* Chur, Switzerland: Bündner Kunstmuseum, 1991.

Tallman, Susan. "Sound and Vision: Multiples by Not Vital and Christian Marclay." *Arts Magazine* 63 (May 1989): 17–18.

——. "The Skin of the Stone: Kiki Smith at ULAE." *Arts Magazine* 65 (November 1990): 31–32.

——. "The Ethos of the Edition: The Stacks of Felix Gonzalez-Torres." *Arts Magazine* 66 (September 1991): 13–14.

——. "Kiki Smith: Anatomy Lessons." *Art in America* 80 (April 1992): 146–53.

Tamarind: From Los Angeles to Albuquerque. Los Angeles: Grunwald Center for the Graphic Arts, University of California, Los Angeles, 1984.

Terry Winters: Graphic Primitives. New York: Matthew Marks Gallery, 1999.

Tisdall, Caroline. *Joseph Beuys.* New York: Solomon R. Guggenheim Museum, 1979.

Todd, Ruthven. "Miró in New York: A Reminiscence." *Malahat Review* 1 (1997): 77–92.

Tomkins, Calvin. *Duchamp: A Biography.* New York: Henry Holt, 1996.

Tsai, Eugenie. *Pictures at an Exhibition: An Installation by Christian Marclay.* New York: Whitney Museum of American Art at Philip Morris, 1997.

Tucker, Marcia. *Richard Tuttle.* New York: Whitney Museum of American Art, 1975.

——. *John Baldessari.* New York: The New Museum of Contemporary Art, 1981.

Turner, Jane, ed. *Dictionary of Art.* 34 vols. New York: Grove's Dictionaries, 1996.

Twyman, Michael. *Lithography, 1800–1851.* London: Oxford University Press, 1970.

Van Bruggen, Coosje. *John Baldessari.* New York: Rizzoli for the Museum of Contemporary Art, Los Angeles, 1990.

Van Buren, Anne, and Sheila Edmunds. "Playing Cards and Manuscripts: Some Widely Disseminated Fifteenth-Century Model Sheets." *The Art Bulletin* 56 (March 1974): 12–30.

Van de Walle, Mark. "Back to the Future: Charles Long and Stereolab." *Parkett* 48 (1996): 6–10.

Varnedoe, Kirk. *A Fine Disregard: What Makes Modern Art Modern.* New York: Harry N. Abrams, 1990.

——, ed. *Jasper Johns: Writings, Sketchbook Notes, Interviews.* New York: Museum of Modern Art, 1996.

Vasari, Giorgio. *Lives of the Most Eminent Painters, Sculptors, and Architects.* 10 vols. 1568. London: Philip Lee Warner and the Medici Society, 1912–14.

Villa, Nicole. *Le XVIIe siècle vu par Abraham Bosse, graveur du roy.* Paris: R. Dacosta, 1967.

Walpole, Horace. *A Catalogue of Engravers, Who Have Been Born, or Resided in England.* London: J. Caulfield, 1794.

Wax, Carol. *The Mezzotint: History and Technique.* New York: Harry N. Abrams, 1990.

Weber, Bruno. *Wunderzeichen und Winkeldrucker.* Zurich: Urs Graf, 1972.

Weitman, Wendy. *Sol LeWitt: Prints, 1970–1995.* New York: Museum of Modern Art, 1996.

Westerbeck, Colin. *Chuck Close.* Chicago: Art Institute of Chicago in association with the Friends of Photography, 1989.

Wetergraf, Clara, ed. *Richard Serra: Interviews, etc., 1970–1980.* Yonkers, N.Y.: Hudson River Museum, 1980.

———. *Writings, Interviews/Richard Serra.* Chicago: University of Chicago Press, 1994.

White, Christopher. *Rembrandt as an Etcher.* University Park and London: Pennsylvania State University Press, 1969.

White, Robin, ed. *Music, Sound, Language, Theater — John Cage, Tom Marioni, Robert Barry, Joan Jonas: Etchings from Crown Point Press.* Oakland, Calif.: Point Publications, 1980.

Wilckens, Leonie von. "Der spätmittelalterliche Zeugdruck nördlich der Alpen." *Anzeiger des Germanischen Nationalmuseums,* 1983, 7–18.

Williams, Reba, and Dave Williams. "The Early History of the Screenprint." *Print Quarterly* 3, no. 4 (1986): 286–321.

Winkler, Rolf Arnim. *Die Frühzeit der deutschen Lithographie: Katalog der Bilddrucke von 1796–1821.* Munich: Prestel, 1975.

Wolff, Martha. "Some Manuscript Sources for the Playing-Card Master's Number Cards." *The Art Bulletin* 64 (December 1982): 586–600.

Wortz, Melinda. "Richard Serra: Prints." *Print Collector's Newsletter* 17 (March/April 1986): 5–7.

Wye, Deborah. *Louise Bourgeois.* New York: Museum of Modern Art, 1982.

———. "*Untitled (Death by Gun)* by Felix Gonzalez-Torres." *Print Collector's Newsletter* 22 (September/October 1991): 117–19.

Wye, Deborah, and Carol Smith. *The Prints of Louise Bourgeois.* New York: Harry N. Abrams for the Museum of Modern Art, 1994.

Yau, John. "Folded Mirror: Excerpts of an Interview with Bruce Conner." *On Paper* 2, no. 5 (May/June 1998): 30–34.

Index